An Intelligent Person's Guide
to Modern Art

An Intelligent Person's Guide to Modern Art

Stephen Farthing

Duckworth

Second impression 2001

First published in 2000 by
Gerald Duckworth & Co. Ltd.
61 Frith Street, London, W1D 3JL
Tel: 020 7434 4242
Fax: 020 7434 4420
Email: enquiries@duckworth-publishers.co.uk
www.ducknet.co.uk

A catalogue record for this book is available
from the British Library

ISBN 0 7156 2944 1

Typeset by Ray Davies
Printed in Great Britain by
Biddles Ltd, *www.biddles.co.uk*

Contents

Illustrations between pages 32 and 33

List of Illustrations

To Joni and Constance

Preface

Deep down, no doubt, all of us have a view of our colleagues, one that captures them with one brush stroke. When I think of my fellow artists, the one image which always springs to mind is that of cannibals, a tribe feeding on its own members, mostly the dead – though not exclusively. If pressed to think longer about it and make the image more complex, I would take a still from the closing sequences of the film *Lust for Life* by Vincent Minnelli. The still would be predominantly pale blue and golden ochre and would show the peasant driver of a big horse-drawn hay cart standing up and looking back down the stook-lined road he has been following through a recently cut cornfield. It is an arresting moment in the film.

What this still will tell us is that it is baking hot and late summer. But what it could not tell us is that it is the noise of a single gunshot that has caused the driver to stop and look back. If you have seen the film, then you will remember it is the moment just after Kirk Douglas (Van Gogh) stopped painting, walked away from his easel and his image of the crows in the sky above the field, drew his gun and shot himself.

This I see as a suitable starting point for this book on modern art. The image succinctly defines the gradual loss of confidence by artists in painting and drawing, and in their previously held passionate belief in the need to attempt to capture nature. It highlights a sense of irony in the appropriations of post-modernism. For anyone who has managed to come to terms with post-modernism's total absence of innocence and pop art's attractive ironies, the image of the cornfield at harvest time will no longer act upon them as a pure symbol of thanksgiving. Once touched by the modern, both artist and audience lose their innocence and as a result understand the harvest

image in a way similar to that of the sunset. What for Turner and Ruskin was a potent reminder of the power and absolute beauty of nature becomes for the modern eye the apotheosis of bad taste.

The image also underlines the obsession the audience has for the artist's biography and for keeping art and artists, even when they are supposed to be radical and of the avant-garde, in the pigeonhole marked 'romanticism'. When Jilly Cooper explained to a journalist why her thirteenth romantic novel was set in the art world, she is reported to have said, 'The art world is wild – I thought about setting it in the literary world, but it wouldn't be the same; artists are very beautiful and stylish people.'

Jilly Cooper, in making this statement, has not so much got it wrong as confused the edges of the art world with its centre. It must, I suppose, sport a few stylish and beautiful people, but I have to confess that at the moment I find it hard to name any. Indeed, I am certain that the art world boasts just as many dull, scruffy, time-serving train-spotters and dysfunctional people as any other world.

What has really exercised all good artists is not their social round but their own work, money and status, in that order. In New York Jackson Pollock was famous for his alcohol-fuelled exchanges with fellow artists in the Cedar Tavern, and in London Francis Bacon was recognised as a frequent visitor to the Colony Rooms in Soho. Today a visit to the Atlantic Bar in Leicester Square or the Bricklayers Arms in Shoreditch may suggest proof that some artists do believe that the road to excess leads to wisdom. In fact, however, alcohol has never seriously informed art. What it has done is serve to fill the gap between studio and sleep time, most artists only really ever being happy when they are totally absorbed by their work in the studio. The 'wild' bit that Jilly Cooper is charmed by is a therapy for failure. As such it is not so much a part of the art world as a part of that real world which has grown up around, and fallen away from, the edges of the art world.

The relationship between artists and money is complex and usually unspoken. Jilly Cooper has another helpful observation on the theme where she says: 'Artists are the new rock stars because of their ability to market themselves ... I am fascinated by rich men, rich people. The moment they get rich they start slapping expensive paintings on their walls. Art and success go together.' It does not

really matter whether her outsider's perception of artists and the art world is accurate. What she is clearly delivering is received opinion and, I suspect, that is in the end what counts. Certainly anyone who bothers to flick through a recent copy of the magazine *Art Forum* will go away with the impression that to work in the visual arts is to work in a very glamorous business. These days in *Art Forum* there is very little editorial comment, just reams of full-page, full-colour advertisements for exhibitions in Los Angeles and New York, occasionally interspersed with advertisements for Prada and Armani and with designer images of light beers.

Richard Dawkins claimed when he wrote *The Selfish Gene* not to be trying to create a theory but rather to present a gene's-eye view of the world and a different way of seeing things. This book aims to do something similar – to build in the reader's mind a picture of the world of modern art viewed through an artist's eye. In doing this I expect to show that, among other things, artists, like genes, are driven not by a sense of cultural duty or honesty but by selfishness. I also expect to show that dealers, historians and critics have, because of their vested interest in keeping art a mystery, demonstrably done next to nothing to increase public understanding of modern art.

Books are the traditional vehicle for the transport of learning and, for most subjects, they work very well. Yet they don't appear to work quite so well for my profession. There are, of course, many excellent books on the subject, and many excellent reading lists. But to construct a coherent picture from these fragments for someone not setting out to be an artist or an art historian is a daunting task. Most of the best intelligence on the subject seems to me to be either locked up in the artefacts themselves or rolling around the art world as part of its oral history.

So I would argue in favour of creating as the best way into the visual arts. Because I am casting an artist's eye on the subject, I have chosen to write this book in a way that is similar to the way in which I paint.

The book should offer some general help, but there will be few specific clues as to where to look – it is not intended as a reference or handbook, simply as an attempt to construct a vantage point for the viewer of what according to artists modern art is today.

Introduction

When I paint I simply decide one day to start work, rather as if I were setting out to create a meal. I then work with the resources I have immediately to hand, shaping each image while working directly onto the canvas. There is (some) research, but no formal design process; the end result should appear fresh and hand-made. This approach relies on putting the whole image down quickly and then, over a period of time (usually months rather than days or years), reorganising and refining its first form by adding a bit here and removing a bit there. If the piece is a success it turns into something that appears to me new and unfamiliar.

This is my experience, but I have no reason to assume that it is very different for other artists. There are two contemporary sculptures which show this particularly well. They break new ground in an unusual way and are clearly designed to shock. In both cases I suspect the artist had hit on something which was to them unfamiliar by the time they had completed the work. The first I believe may be a self-portrait; it is by Maurizio Cattelan, who was born in 1960 in Padua. The second is definitely a self-portrait, its subject and maker being the British artist Mark Quinn. As it happens neither confesses to having studied at art school, but both enjoyed considerable international success as young artists during the 1990s.

Bidibidobidiboo, 1996, 50 x 58cm, is described in a Tate Gallery catalogue as being constructed from 'mixed media taxidermic squirrel'. A small red squirrel sits at an aluminium-framed yellow Formica-topped table on a matching chair, his head slumped forward onto the table. The sculpture is placed in the corner of a massive gallery, with all its component parts (probably liberated from a doll's house) at a reduced scale selected to fall in line with the demands of

the squirrel. We are in a Spartan kitchen in rented accommodation. There is a water heater on the wall and a ceramic butler's sink with brass mixer taps and a grey plastic U-bend beneath. Just next to the squirrel's head is an empty tumbler; between the chair leg and his foot is a handgun, a Walther automatic. The evidence suggests that this is a case of suicide.

Self, 1991, 208 x 63 x 63cm, is described in the Royal Academy of Arts catalogue for the exhibition 'Sensation' as being made of 'blood, stainless steel, perspex and refrigeration equipment'. *Self* is about the size of a small cold-drinks vending machine. The lower half is a grey metal refrigeration unit; on top of this base, sitting at about head height, is a cast of the artist's head made of what he says is his frozen blood. It is roughcast of a dark reddish brown colour with blue tinges at the edges; a neatly machined transparent perspex cube protects this trophy. At first sight, it looks like a preserved fragment from the top of an antique bronze statue, but the evidence suggests that it is a record of a morbid and cryogenic self-interest.

Neither of these works of art, could possibly have started fully-formed in the artist's mind, except as a mixture of vague highly personal ideas, in this case held together by the notion of a self-portrait. To some extent all art objects will be a portrait of their maker and as such, they are often images of unintentional self obsession. This happens because modern artists, unlike architects and designers, spend their studio time solving what are best described as, 'their own problems' and not the problems of their clients or others. What results when the artist goes to work on whatever their chosen subject matter is the emergence of an image that is reliably conditioned by the artist's imagination, temperament, mood, social and economic attitude and position, physical well being and so on and so on at the time of making. All that is usually excluded is their surface appearance.

When artists start work in the studio they usually have an idea of what they are going to work with in terms of subject matter, they will usually also have decided roughly how big the image or object will be, but they will seldom know or be prepared to commit themselves to exactly what the end product will look like. Not knowing what it will look like is what makes it interesting and separates the studio practice of artists from, for example dental surgery or the production

of books. It is the task of the publisher and the dentist to be able to produce a fairly exact outline of what they intend to do, then do it, but for the artist this is neither usually the case nor is it usually required of them. It is in fact considered by most artists to be desirable if an original idea can 'grow' during the making, for many it is within this growth space that creativity really resides, not in an original 'bright' idea or in a well rehearsed set of craft skills but within the 'space' of the making. This is the place where accidents can be capitalised on and not viewed as failure and the hand and eye can take an idea for a walk it is also the area of creativity that during the second half of the last century we gave a lot of time to in art schools.

But in what environment of ideas did these works of art turn into something new? In other words, compared to what are they new? It is most unlikely that they would have been made at the time it was if it were not for the artist's awareness of Damien Hirst. Although this book does not want to do without art history, it does aim to use it as sparingly as possible. An area where it can be useful is in the logging of trends and the exploration of how one artist's work relates to another. In my own mind, *Self* 1991, made by Mark Quinn, was only made possible because of Hirst's bright idea to become a new Victorian, a displayer of collections and an encyclopaedist. He took the vitrine, the stuffed, the sectioned and the pickled out of the museum, cleaned it up and put it into the contemporary art gallery. Quinn clearly acknowledged the value of Hirst's rehabilitation of the museum specimen and deployed a slightly newer technology, that of refrigeration to achieve a similar goal. Both ended up with quasi-scientific curiosities.

Both *Self* and *Bidibidobidiboo* are thus excellent examples of the shape of contemporary art at the end of the twentieth century. They are not illusions. They have a similar power to those saints' bones stored in the reliquary of the church. As apparently real and authentic objects (reproduced in this book) they have become invested with a power that transcends art and our enjoyment of the artificial and which engages us with superstition and the real. Both are quite simple ideas that have been given a concrete form, manifestations of an idea, but not the idea in its entirety.

They clearly show themselves to be a fertile ground for the imagination. They are loaded with irony, which is in my view the single

most important ingredient in the making and viewing of modern art of their period. Van Gogh painted straight from the heart, there was no ironic intention. But after him came a trail of twentieth-century artists who changed the direction of art by simply introducing one new ingredient, irony: Max Ernst, Marcel Duchamp, Joseph Beuys, Andy Warhol, Jasper Johns, Roy Lichtenstein, Bruce Nauman, Gerhard Richter, Gilbert and George and Jeff Koons are just a few. The story of art in the absence of irony did of course continue and in the hands of an equally illustrious set of names: Henri Mattise, Jackson Pollock, Wassily Kandinsky, Mark Rothko, Robert Motherwell, Patrick Heron, Robert Smithson, Ellsworth Kelly and Richard Long are just a few of hundreds of artists who continued to work during the last century without intellectual twist or double take and directly as they believed, 'from the heart'. The teams appear well-matched, but those working with irony have in the final analysis been more influential in shaping contemporary art, than those working without. In the turbulent, organic world that is modern art, these cannibals ended up on top.

It is the application of ideas to an object that is as yet uncertain in shape that is crucial for the artist. For the past ten years I have been in the unusual position of being both an artist and a fellow of an Oxford college. During this time I have spent a considerable amount of energy arguing that fine art should not be thought of as a special case but as a perfectly normal subject to study at university. I have argued that its study requires students to try to make visual sense of the present and reconcile its complexities with the past. Artists desperately need to witness the ideas that are being developed today – though they don't need to be able to take part in that development as such – as this will sharpen their senses.

Nonetheless, during my ten years of campaigning I have noticed a distinction with the working methods of the academic world, which, though it does not defeat my argument, is crucial to an artist. The distinction is that the best modern artists appear to view the world in a totally different way from that of the academics and scholars they (would) associate with at university.

Scholars walk backwards into the future. This progressing through time enables them to examine the past closely while simply bearing in mind and not being too distracted by the present and the

future. Artists, however, only bear in mind the past. Their preoccupation is with the future, which they embrace face on while sparing just a moment's thought for past and present. There are, of course, some artists who are so preoccupied by the past that they do walk backwards, their lack of engagement with the present leading them like artisans to concentrate on celebrating the past and to a life of honing the known rather than exploring the apparently unknown. They choose a method much like the scholar and fail to achieve anything that could be meaningfully called art.

It is this walking backwards that the artist is at pains to avoid. Ideas not only shape the work of art itself, they are also the artist's lifelines from the studio to other artists and the public. An absence of their full appreciation inexorably leads to distorted communication and attrition of creativity. And it's precisely here that a festering problem has emerged. Modern art seems effortlessly to divide its audience between believers and sceptics who, without necessarily realising it, are angered not by the art itself but by the inability of both the artists and their intermediaries to create a solid sense of public understanding of, or sympathy for, their subject.

Yet there are no difficult concepts, rules or calculations that need to be understood in order to engage fully with modern art. So why do most of the audience claim to be baffled by it most of the time? Is it that, for lack of a better word, the 'profession' feels a need to keep its relationship with the audience as complex and as expensive to maintain as possible? In that view, like members of the Magic Circle, artists conspire with galleries to entertain the audience with 'the magic' of art but in doing so also conspire to exclude them from the sleight of hand behind the tricks. Or may be it is just a matter of incompetence? The profession hasn't hit upon the right channel of communication, but will one day do so. I will leave aside the answer which says that an uncomplicated relationship is simply impossible. As every artist craves a response to his work, it is simply unreal.

One example of the growing exasperation on all sides is the Tate Gallery in London. Annually it adds fuel to the audience's mystification, and occasional anger, by organising the Turner Prize, the visual art equivalent of the Oscars. By attempting to introduce a broad audience to contemporary art through the mass media, the press department of Britain's national gallery of modern art succeeds each

17

year in adding a new mocking audience and reopening old wounds by falling into the most basic of traps. It is clear that the tabloid press and peak-time television have no interest in contemporary art – that is unless a painting has an elephant's dropping stuck to it, or a video transgresses some simple boundary of good taste. The Tate's plot of displaying the rough in a very posh frame is by now all too familiar. Its lasting achievement is that it has created a demand in the popular press's for 'media-friendly artists' – and the artists will do the rest. It is as though the British Library were inducing British star authors to write the best trashy sex novel of the year, or the National Film Theatre urged filmmakers to compete for a prize for the best soap.

There is of course nothing inherently wrong with any of these artists or their art, or with the media reporting on the event, or even with shock value. After all, artists don't unwittingly put together work that is tabloid-friendly and include nudity, excrement or images of infamous or famous people. They do it because they know it will turn heads, and also cheque books and pens. Likewise journalists respond to a good story. But if you attend the presentation dinner and see the losers' faces you soon realise that the prize is not for the benefit of the artists. As the film title has it, *They Shoot Horses, Don't They?* The prize has become a vehicle for something entirely alien to art. Ideas don't matter even a little bit.

What the Tate has achieved is considerable success in gaining media coverage annually for the activities of some living artists, but what it has clearly failed to do is generate any depth of understanding amongst its new and bigger audience via the press of what it has chosen to put in the show case. What it could have done is fashion a relationship with a larger audience that was based not on the possibly cheap and sensational but one based on a vital question, what is the point of art? It has become a sterile news item, rather than an integral part and a source of energy for modern art. Despite all of the Tate's best efforts the Turner Prize shortlist still emerges as an object to poke fun at, and not as I suspect would be desirable for artists and audience alike something you want to know more about.

The rules of the Prize require the shortlisted artists to be under fifty years of age and to have been responsible for an outstanding

exhibition during the past twelve months. The problem is, I suspect, how many outstanding exhibitions by British artists under the age of fifty take place annually? Are there really four or five, which is the size of the shortlist?

If John Ruskin, the man who championed Turner himself, is right, and societies really do get the art they deserve, it is not surprising that there is an annual round of complaint when the Turner Prize shortlist is announced. By emulating popular publishers and the pop music industry, the Tate Gallery has speeded up the metabolic rate of the art world to such an extent that artists are no longer capable of satisfying demand. As a society we expect a fast turnaround of ideas and instant gratification. Unfortunately art is not particularly well geared to delivering within these artificial dictates, or at any rate dictates supported by little else. The prize draws too much attention too frequently to a profession that performs best at a slow speed. The prize is simply out of sync with the artists and geared totally towards the public relations and marketing aspirations of the Tate Gallery. And this is not surprising. As a museum which is sponsored by the taxpayer it is under pressure to perform, even if this means amplifying the hype and becoming predictable – precisely what art shouldn't be. *Pace* the many excellent winners of the Prize, like the *Red Queen*, the Tate has come to expect revolutions that occur with the regularity of clock work.

I am not surprised that artists have joined the game and allow their names to be put forward – who could resist the temptation? For artists hype and the media are an essential part of life. Throughout the entire history of art, they have conducted themselves according to the precept that the media will be bound to concentrate on the sensational and the trivial. Even a relatively safe and old-school artist like Ruskin Spear, RA, who was my first-year tutor at the Royal College of Art, was not exempt from such behaviour. In the spring of 1973 he confided in me (as he probably did in many others) that each year he included among the six paintings he was entitled to send in to the Royal Academy Summer Show one whose sole purpose was to catch the press's eye. Two I remember are *Man with a Pipe*, a portrait of Prime Minister Harold Wilson belching smoke, and *Lady in a Blue Hat*, an image of Margaret Thatcher. Both were

fairly speedily executed works in the manner of Walter Sickert, based on newspaper cuttings. It did the trick.

But no artist will feel helped by the bafflement that surrounds modern art today. All artists I know value their privacy but chase fame. They wilfully project an image of themselves as being both clever and dumb, simultaneously aristocratic and working-class. They seem to need lots of praise and want to be viewed as complex, difficult, earnest, clever and gifted people, but most claim to be hard-done-by and as a result needing special-case status. They want to be treated as scholars while functioning as merchants; want to be both free of and parasitic upon society. They aspire to be great lovers and popes, children and chairmen. Equally, they should both resist nonsense like the Turner Prize and embrace it, if its suits them. But it is the artist who should be in control. They want to make meaningful contact with their public.

And the exchange of ideas is their vehicle. The art of being an artist is the art of blending absolute innocence with total cunning. Every artist must be able to ask themselves when they complete a new piece of work a set of questions. Is it any good? Is it new? Does it achieve the objectives I set myself or go beyond them? Is it just a remake of something I or someone else has made before? what will my audience, my dealer think of it? will it extend my audience? will it add to my reputation? Will it make me famous? These are the same questions art students ask themselves before an assessment and the final examination. What of course both the professional artist and the student hope is that they will see before them something that goes way beyond their original intentions and expectations and something that has emerged from their imagination which is genuinely new.

The final question they ask is, will anyone take any notice of it. Because art in most people's minds is something they can live without, don't understand and cannot afford, the publicists and marketers of art realise they need a fairly substantial peg to hang it on if they are to interest a large and general audience. This is where sex, lies, violence, video tapes and dung come in and the door opens one of those occasions where there is no Mr Clean. From the producer to the consumer and through all the stages in between the conspiracy is finely tuned. The label art adds a veneer of respectability, but in

the end I would argue the conceptual base is no more sophisticated than the *Sunday Sport*. Artists try to catch the publicist, publicists in turn trap editors and editors trap readers. So art, just like a juicy murder or messy divorce or a pair of large breasts gains its place in popular publishing by avoiding the mistake of appearing intellectually challenging and instead appealing to the fairly basic set of carnal and voyeuristic human emotions that most of us have somewhere about us.

Returning to *Lust for Life*, anyone who studied art at school at the time and then stopped will probably imagine that the occupation of being an artist today has something to do with what they know about Van Gogh. That it is a life of intense emotional engagement with, and struggle to finance as a sole trader the production of, what society values as beautiful, meaningful and mysterious objects. What I argue in this book is that nothing has changed, and that the aspirations of most artists remain identical to Van Gogh's. Mercifully few artists seem dogged by his terminal psychological problems, but just about all of them seem to have a similar, albeit unspoken mission statement. What has changed, though, is the need for artists to be seen as special people, who are perhaps driven by a special faith and who are genuinely totally self sacrificial for their art. This has more or less disappeared. Their new role has released them to work strategically and often openly towards goals without necessarily believing in them beyond career expedience. They have in fact like pop musicians declared their mortality and taken the money, but many still rather fancy the Van Gogh model during their more reflective moments.

I have tried to give a sense of modern art as a phenomenon challenged from within, a phenomenon whose sole purpose is to perplex or pretend to perplex its audience, and a phenomenon that constantly questions itself and regularly pretends to be shaking itself to bits. I believe that what's wrong, if there is anything wrong, is the fault of the makers, not the presenters. Artists decide what they want to make, what they want to show, and where to show it. It is their work and they choose how they interface with the world. When things do go wrong I suspect it is greed that twists judgement and warps the picture.

The ultimate aim of this book is to demystify art, but the good news for me is that readers will learn to do it for themselves, so I am hoping

not to have to adopt the hectoring tone of an angry suburban reactionary. What I will do is describe some art, some artists and the environment in which they work, and in doing so offer up a way for the reader to look at art which should strip the mystery right out of it and replace it with meaning.

1

The Identity of the Artist
A Portrait

The best moments in the making of a painting are at the beginning and the end: the middle for most painters is messy. Here at the start you have a perfectly stretched, taut white surface before you – bare canvas. Sit back and enjoy it for a while. Enjoy the moment, the fact that so far nothing has gone wrong. Relish the thought of what might come. This is a time to fantasise. For you are not yet quite at the point for what Ruskin called 'dirtying the surface delicately'. If there are to be visitors to your studio, let them come now. Visitors are always impressed to see a waiting empty canvas. None of the infelicities of product; absolute potential. So, to work. Imagine just how the first few marks will be placed. You already have a starting point in mind, but how will things actually happen in practice? Run through some alternatives. How will this work unfold and take shape out there on this vast whiteness?

Who should be the starting point for a portrait of 'the modern artist' on this immaculate surface? France around 1900. Probably Paris. He is male, almost certainly. A painter. Just possibly a sculptor. Certainly not a photographer. Aged about twenty or so, from middle-class stock or with just a touch of the aristocrat about him. Unmarried. He will have studied at an academy of art – a lengthy training focusing on the acquisition of skills. Intellectually he will have, of necessity, become something of an autodidact. He is living in modest rented accommodation but with the security of a small private income.

Standing at the easel, he has discarded his jacket and tie but retained the trousers of a suit once smart.

In short he is a gentleman. One who can afford to risk his financial and social status. One who feels relatively secure. But why take this risk? Why the desire to adopt this odd life? It is all somewhat enigmatic. But perhaps he believes there is more to life than making money. After all, this was the attitude of his forebears (and thank goodness, or he wouldn't be standing here today). Or perhaps he is envious of the recognition that artists in the past have received for work that he is attracted to. Whatever the reason for his ambition, here he is, brush in hand, easel before him. And his subject just beyond. His frown testifies to the battle he is about to wage: will his skill in imitating nature prove crafty enough to support his emotional and intellectual input and still produce a work that will be a joy for ever?

Or select another sitter for this portrait. Wind the clock on half a century, and strike out across the Atlantic to New York. Still male, still painting, still fairly secure, our artist is gazing out of a dusty window in some huge late-nineteenth-century industrial building. A warehouse perhaps, cleared for use as a studio. The artist draws moodily on a cigarette. He wears jeans, T-shirt, leather jacket. A style championed throughout the West by artists. In Europe, Fernand Léger celebrated the industrial aesthetic in his bleu de travail overalls, while in America frontiersman Jackson Pollock went for the T-shirt and jeans of our sitter.

This shift in personal style, which took place over the years that divide our potential subjects, is not unimportant. As the twentieth century has progressed, the identity of the artist has become inextricably bound up with his or her look. From a European gentleman at the turn of the century the artist has, by the end of the century, become a buccaneer of art, contrarian, quiet and concentrated, almost autistic.

As the artists' image changed, however, so did their relationship with their audience. What happened was that the history of art gradually stopped being recorded as a series of objects and events – *The Light of the World*, *The Death of Nelson*, *Washington Crossing the Delaware*, *The Raft of the Medusa* and *The Death of Marat* – and instead became a list of artists' names. To think about art was no longer a matter of recalling an object and considering its detail; instead in the eye of the public it became to be focused more and more

24

on names – Picasso, Ace, Matisse, King, Beuys, Queen, Pollock, Jack, Warhol, Ten, and so on. Specific works, a visual memory and the names of paintings and sculptures ceased to be the first point of contact. In their place artists were pictured as cultural specimen, like butterflies pinned out on a board. With taxonomical precision their work could be classified in apparently logically distinct sections, such as Picasso's blue period. Thus the task of preparing a portrait of the modern artist is more complicated and involves far more than just constructing a likeness. It must also incorporate the essence of their art.

With this in mind, the idea of this mid-twentieth-century American as a possible image to build on emerges as an attractive starting point. The stills taken from Hans Namuth's film of Jackson Pollock at work in his studio a few years before he died, offer the perfect representation of the spider in his web. We see the artist darting and weaving his way across the studio, dipping into a gallon can and dripping onto an unstretched canvas on the floor: Pollock in black T-shirt and jeans, his whole body sketching the motion of each dip and string of drips, his movement frozen mid-flow in each frame against a backdrop of stretched and completed versions of what he is doing on the floor. In each black-and-white image the lights are provided by any untouched areas of canvas and the artist's face, his bare arms and balding head, and the blacks by the paint he has applied, the floor around the canvas, and the gaps between the completed canvases in the background. Namuth's photographic portrait functions in a similar way to Velazquez's *Las Meninas*, a large painting that as a complex portrait goes well beyond its original intentions of representing a slice of history. Namuth doesn't just tackle his subject, but art as well. In his image of Pollock, the artist and his art blur into one, with not a trace of irony.

Inspite of this absence of irony, this image could have remained serviceable for the rest of the twentieth century, as it sums up so well not only artists' aspirations but also their expectations of themselves. During the second half of the twentieth century, the most important change in the collective identity of the artist was the gradual but significant recruitment of women into the art world: not just as artists but as curators, writers on art and collectors, all of whom have a conditioning effect on the profiles and work of artists. Throughout

the century, on both sides of the Atlantic, there was always a female presence in art: Frida Kahlo in Mexico City, Sonia Delaunay in Paris, Barbara Hepworth in St Ives, Louise Bourgeois in New York. Yet only as recently as perhaps fifteen years ago, these artists were accommodated by awarding them the status of honorary male. The full engagement of women in modern art brought with it some changes in the way the art world conducted and dressed itself, but, rather as in the medical and legal professions, this extended membership has exhibited a conservative attitude in terms of social style and of women exercising their rights. It is noticeable that race is finally making a similar inroad at the moment.

Once a portrait is under way, it would not be unusual for an artist to start opening out the possibilities a little and looking at other people's ideas on the subject, to see if the image forming has already been worked to death by another artist, and to seek a fresh viewpoint. Having painted an image at the start of the century of an artist who is more or less one hundred per cent male, it is interesting to reflect on the fact that when, from time to time, writers in the past have mused over the identity of the first artist, there is no shared assumption as to which gender or gender preference this first artist might enjoy.

In his book *Addled Art* (1946), Lionel Lindsay dismisses as a poetic fantasy Whistler's view that the first artist must have been a dreamer who stayed at home with the women and traced strange devices with a burnt stick on a gourd. Lindsay's first artist takes us farther back into history, to a powerful and frequently invoked male image of Cro-Magnon man, a hunter who draws his quarry on the walls of his cave. A more sophisticated and poetic writer who worked imaginatively with this question was Pliny. His myth identifies the first artist as a young woman whose male lover was going off to war. At the point of his departure, and in a bid to hold on to at least an aspect of his presence, she drew around the cast shadow of his head in profile on a wall of her home.

If there is a shared assumption between these three theories it is that each artist has found an imaginative way of capturing and illustrating an absent or illusive aspect of the world in an image. Whistler captures the image of the imagination, Lindsay the image of survival, and Pliny the image of love. I cannot name the first artist

26

as much as anyone else can, but in the footsteps of their forensic tradition I would draw my own profile to deepen my understanding of the sitter of the portrait in this chapter. The first artist was the first person to recognise the potential in making an apparently useless image or object with a view to enriching their own experience of life, and with a desire to communicate that experience to another person or group.

This quick sketch says to me that artists have always been craftsmen. But it also means that modern artists are improvisers who must continually acquire new technical skills in order to do what they must do. They need to be more resourceful and inventive than the artists of the past, less controlled and less refined. When they set out to work they want to amaze their audience with ideas and images, not their craftsmanship and technique. The successful ones employ technicians who can take care of that side of things for them. As late as the middle of the twentieth century there were many teachers of art who fervently believed that the education of artists should centre on the acquisition of craft skills through repetitive practice. In their view, by gaining full control of a craft – carving stone, painting on paper or modelling clay – their students would gain control of a visual language, which is what I assume an artist needs if they are to communicate effectively with an audience. Content, which most would see as the point of art, is under their tutelage left to fend for itself.

The world's greatest female sculptor, Louise Bourgeois, who was born on Christmas Day almost one hundred years ago, writes perceptively on this subject.

> The relationship of one person to his surroundings is a continuing preoccupation. It can be casual or close, simple or involved, subtle or blunt. It can be powerful or pleasant. Most of all it can be real or imaginary. This is the soil from which all my work grows. The problems of realisation, technical, even formal or aesthetic, are secondary; they come afterwards and they can be solved.[1]

It may be possible to explore the degree to which a person working as an artist actually is an artist by establishing the degree to which

their practice is driven or overshadowed by the craft they are deploying to make their art. Looked at another way, the shadow which is cast could simply be the degree to which form and finish predominate over content in both the completed piece of work and the artist's intentions.

If you take this premise seriously, it follows that the human history of art actually includes as many craftsmen as artists – possibly far more, as I am certain that there have been a lot of artists who unwittingly spent their entire careers doing nothing more than practising a craft. Whether one should call such artists' work either 'low art' or 'high craft' may be difficult to establish simply by reviewing their intentions. This is because the evidence only exists in the work. This idea may be illustrated by comparing Burne-Jones and Turner, or Leonardo and Michelangelo. To my mind it is Leonardo and Turner who are the artists and Burne-Jones and Michelangelo the very fine craftsmen.

Within Victorian art this is perhaps best illustrated by comparing two paintings in the Tate Gallery in London, *The King Cophetua* and the *Beggar Maid* by Sir Edward Burne Jones and a watercolour by Turner of the *St Gottard Pass at Faido*. Painted half a century before the Burne Jones the Turner breaks new ground in the way it blends fact and fiction, water and rock, clouds and mountains and foreground with background. What Turner did in this image was find a way of describing with paint the turbulent Alpine landscape and weather. Something that Leonardo da Vinci could never do and only began to suggest in his line drawings of the deluge for example. What Turner demonstrated was not craftsmanship and not just a clear understanding of how landscape and weather fuse through water in its various forms, but that he could invent a way of describing the fleeting and illusive.

Burne-Jones by way of a contrast constructed in *King Cophetua* an opulent, highly manicured and fetishistic image of the past. It is claimed by some historians to represent the artist's rejection of worldly wealth. If this is the case then why does he craft a picture that looks more like a Fabergé egg than a slice of life? What Burne-Jones produces is a valuable looking and highly finished object that breaks no new ground and required virtually no original thought. It

is in short a beautifully crafted but mindless object that has all the secondary characteristics of art but none of the primary force.

What these examples make clear is how important it is to break down the current concepts that provide our handle on art, in particular the idea that artists today belong to a profession as they did before the era of modern art. In order to preserve what is vibrant in art we need to build up an image of the artist as self-employed and self-driven – a person who works within an intellectual, conceptual and emotional frame that they have designed themselves. Such a profile of the artist is necessarily less like Lindsay's Cro-Magnon, because we don't know why Cro-Magnon man made his images – and this is an important point. Nor is it like Whistler's dreamer. The earliest match of today's profile of the artist I have sketched is Picasso, whose motivation we can at the very least pretend to understand.

Between Cro-Magnon and Picasso there are but a few artists worth speculating about today and they may include Leonardo, or Breughel, or Goya. Each was a real inventor, each turned a personal vision into a body of work that to some extent changed the direction of art for ever. They were less cannibalistic than their peers and made concrete new ideas in new forms that demonstrably sustained subsequent generations of artists. They didn't so much quietly munch on the past as conquer new realms for others to feed.

In my opinion, the first modern artist might be Pliny himself, on the grounds that his beautiful and elegant myth feeds the imagination and catches the essence of the artist's profile. It leaves his protagonist's drawing as nothing more than a very useful record, and certainly not art. He is inspired, or rather feeding on the work of someone who preceded him. This explains more powerfully than any other story the modern reality where art has shifted from the object to the maker.

Where does this leave the nineteenth-century other-worldliness of the artist? As an artist it is comforting to imagine that Van Gogh may have been right when he confided in his brother shortly before he shot himself that Dr Gachet, his psychiatrist, was 'even madder than he was'. In order to be an artist you don't need to live on the margins of society, but it seems that received opinion would affectionately like it that way. I was recently intrigued by a travel journalist's description of the *clientèle* of a bar in Cape Town. He said, by way of painting

what I suppose aimed to be an alluring picture of the place, that it was frequented by 'sailors, prostitutes, pimps, musicians and artists'. It is a tired but persistently ideal arrangement of variously skilled people, of which one may wonder whether they really ever existed in the picaresque harmony that is suggested.

For a month or so before we were married, my wife and I used to drink occasionally in the Brasserie Ile St Louis in Paris. It had the words 'Relais des Artistes' painted on its windows beneath some Alsatian decorative motifs, which were, as I remember them, an entwinement of flowers and sausages. On one occasion we did meet some artist friends there, but more memorable was the evening when the place was bursting at the seams with rugby supporters from England, or those other evenings when elderly French businessmen turned up with young women who were clearly colleagues from work. In general the place was full of the bourgeoisie of the 4ème, with not an artist in sight. Cafés, bars and restaurants are eager to give the impression that they are a meeting place for artists, presumably in order to suggest a place, home away from the home ordinariness, where one can have one's cake and eat it. Perhaps Damien Hirst should be encouraged to add the strapline 'Relais des Pharmaciens' beneath the sign of his Notting Hill restaurant.

The Modern Artist's Life

Giorgio Vasari's Renaissance bestseller, *Lives of the most Eminent Painters, Sculptors and Architects*, has played a leading role in establishing artists' biographies as the key to understanding their art. More recently in the English-speaking world, films about artists – *The Agony and the Ecstasy*, *Savage Messiah*, *The Rebel* and, more recently, *Great Expectations* – offer a fairly concise picture through their titles what received opinion on this subject amounts to. As in each of Vasari's 'lives', the story is told in four parts. First, the early years: starting with where the artist was born, the narrative usually allows us a glimpse of the youthful pre-artist years, then takes us through to a point where signs of early genius are revealed. This is perfectly illustrated by Vasari when tackling the early days of Giotto. Fourteen miles into the countryside beyond Florence, in 1266 or 1267, Cimabue comes across Giotto aged ten, drawing a sheep with

a pointed stone on a flatter stone while tending his flock. Astonished at the youthful shepherd's draughtsmanship, he takes him off to study in his studio in Florence.

The second part of Vasari's work deals with the artist's acceptance by the art world, and takes us quickly through either formal training or a period of autodidactism, then lingers on the business of the artist finding a patron. During this part the audience is allowed to visit the artist's studio and see 'the hand' at work, before witnessing the response of the artist's audience (usually made up of friends, mentors and a patron) to his achievement. According to Andrew Sinclair, for example, during the 1930s the paintings of Francis Bacon were first shown to the Director of the National Gallery in London, at about the same time that Bacon had his first exhibition with his companion and mentor Roy de Maistre, an Australian living in London. Some important figures in the London art world gave Bacon's work an exceptionally favourable reception: the dealer Freddy Mayor, the art critic Herbert Read and the collector Sir Michael Sadler proved to be rich and useful contacts for an emergent artist during a period of economic depression.

The third section, which could be described as the long haul, deals with the problems inherent in maintaining through mid-life a market position, and usually dwells on the issue of balancing time in the studio with a love life, or lack of it, and some form of substance abuse. Take the Carmelite Friar turned painter Fra Filippo Lippi, who was so devoted to sex that his patron, Cosimo de Medici, was driven to locking him in his house in a hopeless attempt to keep him at his painting and away from his hobby. Lippi, however, made a rope from his bed-linen so as to escape into town and thus satisfy his addiction.

The fourth and final part requires either a happy or a not-so-happy ending – some die young, while others make it through to seniority and old age. During this part a final masterpiece is produced, but the work is most likely misunderstood and undervalued in its time. In the case of Paolo Uccello, his plan was to put everything he knew into what turned out to be his last fresco, a picture showing St Thomas feeling for the wound in Christ's side. To help him focus on the task in hand, and no doubt to add drama to the event, he painted the picture behind specially constructed screens. Unfortunately, the project backfired. The work failed to live up to the audience's

expectations, boosted by their exclusion from the work-in-progress, and as a result Uccello spent his final years as a recluse. Donatello's tactless response (as the first person to see this 'hidden masterpiece') was to question Uccello's wisdom in ever uncovering it.

None of these four 'stations' of the artist's life deals directly with their art. Vasari's thesis appears to be that, when an artist's biography is montaged over regular glimpses of their work, an interested audience will develop an understanding of what makes the artist 'tick', and so by understanding their motivation will somehow understand the work.

How would a modern Vasari write the artist's life? This artist is a rebel and as a result his story doesn't quite conform to the ingrained template of a late starter and an outsider – there is no juvenile discovery of talent, although the other stations, the emergence, the long haul and the fall may all be there. Interestingly, this immediately raises the question of the age of the artist in the portrait. Most portraits are of middle-aged and old people. A very common response from sitters who are finally considered important enough to be included in the National Portrait Gallery's collection is 'if only you had done it ten years ago'. Artists, like most people, would rather be remembered without the inevitable signs of decay being too evident. Moreover, some of the most important discoveries, achievements and inventions are made by relatively young people, but the image we retain tends to be of them in old age. Picture Einstein; picture Picasso – it's only those who die young like Pollock and Marilyn Monroe who leave behind a relatively youthful image.

The Rebel made in 1960 by Associated British with the US title *Call Me Genius*, written by Alan Simpson and Ray Galton, directed by Robert Day (105 minutes, Technicolour) is a perfect vantage point for this debate with the past. On a suburban railway platform nineteen minutes south of central London, a bowler-hatted commuter boards the 8.32 to Waterloo. Next the camera surveys a modern open-plan office, moving us away from the regular pattern made by the rows of clerks sitting at identical desks and lingering on a perfect row of bowler hats hung on cloakroom hooks. Also on each hook, at about thirty degrees to the vertical, is a tightly rolled black umbrella. The row is notable for just one detail; midway along, one umbrella is hung in the opposite direction to the others, corrupting

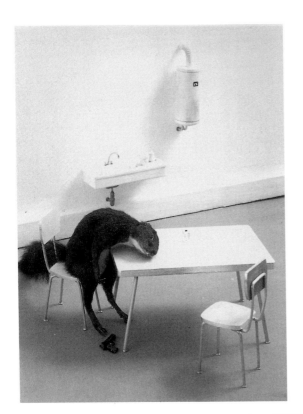

1. Maurizio Cattelan, *Bidibidobidiboo* 1996 (No. 2). A sculpture that assembles the real to construct a narrative not on a plinth.

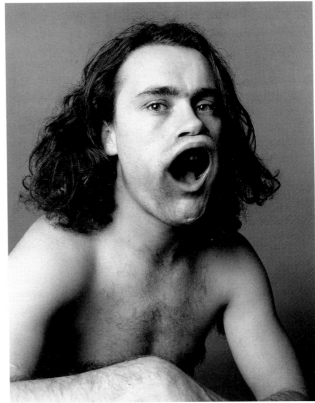

2. Damien Hirst, *Portrait of the Artist*. By conspiring to exhibit himself in this way, the artist is clearly making references to a successful line in his own works of art.

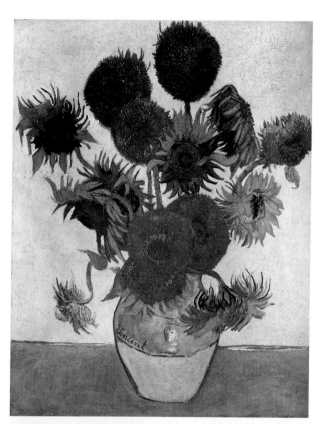

3. Vincent van Gogh. *Sunflowers*
92.1 x 73cm. © The National
Gallery, London.

4. Janine Antoni, *Loving Care*
1992, 'I soaked my hair in hair
dye and mopped the floor with
it.' Detail of performance,
Anthony d'Offay Gallery,
London.

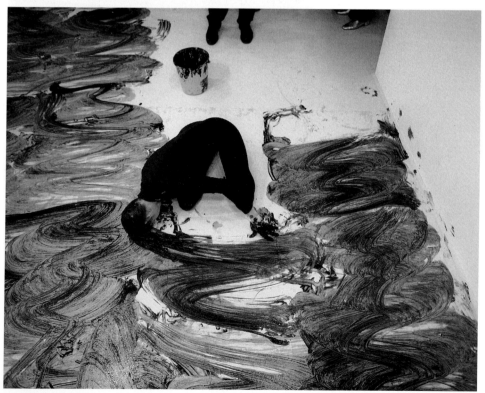

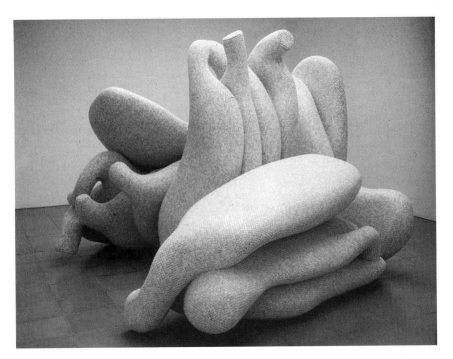

5. Tony Cragg. *Secretions* 1998, 248 x 295 x 335cm. A sculpture that is bigger than a person, sweeping and non-referential in its form, but obsessively detailed on its surface.

6. Jordan Baseman, *the history of existentialism* 1999, still from the video 'the history of existentialism'.

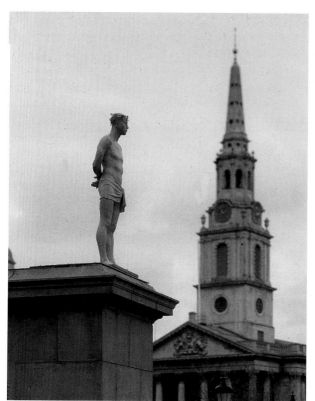

7. Mark Wallinger, *Ecce Homo* 1999, life-size, installed in Trafalgar Square. A life-size image of Christ is placed on what was the empty plinth of Travalgar Square.

8. Stephen Farthing, *Picknick at Panda City* 1990, oil on canvas 206 x 173cm. This oil painting sees the action in the Uruguayan pampas and draws its structure from a drawing by Leonardo da Vinci.

the pattern and making a 'V' of two parallel diagonals. On his way past, the office supervisor corrects the deviance and, with a filmic glance from him and a reaction shot, the camera identifies the Rebel as the culprit.

Having returned home on the 5.20, the Rebel dives into his room, whips off his suit and replaces it with a paint-splattered smock and beret. He then throws open the door to his back bedroom to reveal an artist's studio. In the centre is a massive part-finished post-Cubist, sub-Picasso stone carving of a woman. As he starts chipping at its face with a mason's hammer and chisel from the top of a stepladder, we learn that it is *Aphrodite at the Waterhole*, carved in secrecy from blocks of stone smuggled into his lodgings by night. The suspicious tapping of steel on stone finally gets the better of his landlady's curiosity. She bursts into his room and meets *Aphrodite* head on. Immediately defensive, the Rebel says, 'It's not doing any harm; it's a work of art.'

The angry landlady then turns her attention to a modernist painting of birds, one of many canvases hung around the walls. This time the Rebel gives the picture a title in order to defend it: 'I call that *Ducks in Flight*.' Quick as a flash, the landlady goes on the offensive: 'I've never seen beetroot-coloured ducks before.' In desperation, the Rebel explains something of the creative process. 'They fly at a fair rate, those ducks. They are up and out of the water and away – you just have to whack on whatever you've got on the brush at the time.'

Depressed by this exchange, the Rebel retreats to a Formica-clad coffee bar to consider the situation, and settles for a cappuccino 'with no froth' and a soliloquy. 'What a life. Where does an artist like me go to get accepted? There must be somewhere ... Wait a minute – where did the others go? Rembrandt, Gaugin, Vermeer and all the other mob – where did they go to be appreciated?' His eyes fall on a poster of the Eiffel Tower. 'That's it – Paris.' And off he goes.

In a Paris café, among the gingham tablecloths and the grey smoke from black tobacco, our hero introduces himself as Anthony Hancock when he chances on English artist Paul Ashby, who later introduces him to the Paris art scene. In conversation with other artists he is hungry to accommodate the new. As a complete ingenue, he brings a limpid honesty to the scene, and soon he has a cult following of action painters and existentialists. Cunningly, however, he decides to be-

come involved in conceptual art. He meets a big-time art dealer, and falls for Chelsea, a beautiful female existentialist with a black jumper and blue lipstick. He becomes a regular partygoer and is soon at the hub of the Paris art scene – forget the gingham tablecloths.

He dispenses with the easel and uses his whole body as a brush. His success depresses Paul to such an extent that the latter leaves Paris and returns to England, and Anthony is left in the hands of a brash blue-chip art dealer who sets about representing him. 'If I like your painting,' he says, 'you're made, and you've got nothing more to worry about.' The outcome of this business arrangement is that Anthony becomes a cigar-smoking success, and changes his paint-slashed checked shirt and jeans for a red waistcoat, beige suit and black fedora.

Unfortunately his success is based on a misunderstanding over the authorship of his paintings (they are in fact Paul's). Honesty prevails and our hero leaves Paris to return to suburbia, wearing a blue-grey suit. In the final scene he is back in his studio and his checked shirt, chipping away at version three of *Aphrodite at the Waterhole* in his bed-sit studio, not so much out in the cold, but back in front of the gas fire.

What is effective about this film is the screenplay's ability to pinpoint the crucial stages and stumbling blocks in the artist's life and its ability to tackle (through irony) issues that tend to be consigned to history and are seldom touched upon by biographers of living artists. How good do you need to be to become famous as an artist? How important is it to know the people with power? To what extent is success a question of playing the game? How important is where you live, or where you studied? If the film has one clear answer, it is that artists should never try to help others or explain honestly to a soul what they are trying to do, as if they do they will surely undermine their whole careers. All successful artists are and must be totally selfish.

The story of the Rebel leaves two unanswered questions. Is it possible to decide to become an artist – and not only do it but sustain it? And if this is possible, can you then go on to decide what kind of artist you want to become?

The answer to the first question is clearly yes, but deciding, achieving and sustaining are quite different things. Plenty of young

people going to art school in the hope that they may one day have a picture hung in the Tate Gallery will be disappointed. This is not saying anything demeaning about art schools and apprenticeships. These have consistently demonstrated that artists can be trained. But what is clear is that the clever ones, the ones we hear about, are normally far more than just willing participants and, like high achievers in any field, are likely to do well because they are hungry, excited by the subject and success-oriented – a concept that Virginia Woolf encapsulated neatly when she said that lots of people want to write a novel, but it's the ones who need to write a novel who succeed.

The second question is more complex. During their formative years all sensible aspiring artists decide what kind of artist they want to be, but more often than not both the subsequent history of art and the artists themselves go into denial after the event. Hindsight seems nearly always to offer the opportunity to record the development of the artist's identity in terms of some kind of God-given destiny. An element of the popular romantic myth about artists, this distortion tends to take effect at some point after the neophyte emerges from formal education and hits the commercial world.

Today art schools structure their fine art courses around one assumption, which is that they should enable aspiring young artists to discover a suitable identity for themselves as artists. This is done by encouraging students to look at, write about and discuss what artists did in the past; by encouraging them to look at what is going on now and to relate what they see to the past through discussion and essay-writing; by giving them the time and technical support to experiment with a wide range of materials and tools; by introducing them to successful artists to provide pick-and-mix role models. Students thus design themselves as artists from a range of options. The history of art tends to give the impression that all artists, and especially those who appear or claim to be primarily driven by their emotions, have no choice in how they exercise their skills as artists, their overall approach being controlled to such an extent by their emotions that it is simply a matter of starting to paint and seeing what happens. At a day-to-day level this may be exactly what does happen, but all artists plan and have long-term strategies, which quite sensibly they keep to themselves.

The Midas Touch

Once artists have established in their own minds their preferred identity, the next step is to establish a niche for their work in the marketplace. To do this, a certain amount of social networking needs to take place. Today it is pointless buying a fisherman's smock and moving to Cornwall, or renting a back room in suburbia – experience shows that successful artists cluster in ghettos in metropolitan areas and are at the centre, not at the margins, of culture.

The Midas Touch is the most important attribute an artist can have; it is the ability to turn any material, even rubbish, into something that can be understood as an art object. There is no prescribed method for doing this, but it is what art schools wrestle with teaching every day. Evidence of the power of the Midas Touch can be seen most easily and vividly in the work of Picasso, in the leather bicycle saddle and drop handlebars arranged on a wall to become a bull's head, or the model car that becomes the perfect head of a baboon.

This alchemy is not a matter of simply turning base materials into cash; it is the construction of significance from detritus. What Picasso performs is an illusion. By apparently turning one thing into another he engages the audience with an old and familiar object, then gives it a radically new meaning before their eyes. In both examples the artist's skill was to recognise the potential in an existing object to become a component part of a new and previously unrelated object. As an audience we applaud Picasso's sleight of hand and visual imagination in bringing this transformation about.

What you wear, where you studied, where you work, with whom you socialise and who buys your work are all part of the complex business of acquiring the Midas Touch. During the summer term of 1978, the acting head of painting at one art school described to me his theory about how this worked. It was, he said, as though the teaching staff, most of whom were well-known and/or successful artists, were holding a drinks party in sparkling sunshine on the deck of a yacht moored a couple of hundred yards offshore in the Bay of Antibes. The lecturers passed their time chatting to each other about their own art and exhibitions they had recently visited, while sipping cool drinks. The students passed their time playing on the beach. Most were oblivious to the boat party; some played on the sand, some

in the water, and others sat reading or staring out to sea. A few wandered into town and visited the art galleries and shops, while one took a bus to Biot and found the Léger Museum.

As time passed a number of the students became aware of the offshore party, which resulted in some of the stronger swimmers deciding to make their way out to the boat. The sea was fairly choppy and only one or two made it to the boat; the rest returned to the shore (the acting head of painting didn't mention if any drowned). The students who made it were welcomed and treated as honoured guests, their fresh minds, firm flesh and obvious gratitude highly valued by the celebrated, if slightly jaded, company. Refreshed, the party continued, and a few more young artists were well on their way to being launched in society.

The Midas Touch is an extraordinary gift that continues to puzzle observers of the art world. Of course, designers, too, thrive on their signatures – or labels. Ralph Lauren, Pierre Cardin, Versace, Gucci and Hugo Boss push the idea a little farther by using their names to endorse products that have nothing whatsoever to do with the reason for their becoming 'household' names in the first place. An extreme example is the way in which the name Picasso, arguably the top brand name in modern art, has been used by his daughter Paloma to suggest quality, originality and exclusivity in a range of cosmetics. What worries the art watchers is that there may be nothing more to it than the signature. Ten years after Salvador Dali's death, a Spanish judge and police officers from an organised crime detection squad interrogated his London-born octogenarian personal secretary on the matter of the alleged forgery of ten thousand lithographs and paintings. Experts brought in from Barcelona University had their task complicated by rumours of Dali's willingness to sign blank papers prior to his death. Is it *all* art? Should one feel an obligation to consider an amalgamation of person, reputation and thing, along the lines of 'It must be good.'

But it is precisely this question which has proved to be the lifeline of modern art, a new territory on which the art world could nourish itself. When I left art school in the mid-1970s I was encouraged by an art dealer to continue painting, but assured that it would be a waste of time approaching commercial galleries for a show for at least five years, as no art dealer would trust a recent graduate. By the mid-

37

1980s it had all changed – galleries were hungry for new blood, and all artists expected to be treated like stars. Prices soared, and it was clear that the art world was evolving into something like the pop music business – the stars were getting younger and had become known internationally as YBAs (Young British Artists). Charles Saatchi did a lot to develop the art economy generally by building up a collection based not merely on safe investments but also including work by young, emerging artists who were making rough, difficult, cutting-edge and sometimes offensive work. With the British Council pushing these young artists' reputations abroad, the focus on youth brought with it energy and optimism, and art became fashionable again. An interesting side effect was the large number of older artists who were rehabilitated or picked up by the new wave. Paula Rego and even Carel Weight were touched by the Midas hand of Saatchi, although others were sidelined by these developments, creating a new class of 'old rocker' artists – something the pop music world was used to but which was really a new phenomenon in the visual arts. Finally modern art had its own Gary Glitter.

What seemed to be quite a big issue in the middle of the century, the abstract versus figurative divide, withered on the vine. Men and women and members of all ethnic groups can consider becoming modern artists. As an occupation, art threw its doors open and became in theory accessible to anyone with ability and ambition. It expanded the range of options of the type of artist one could be. Having started the century with just two types, painters and sculptors, the art world rapidly added to the list photographers, video, sound and performance artists, film-makers, print-makers, computer and community artists – a roster that is still expanding.

Today, as a result, new artists must take control of their own lives. They must control their own image, and construct it from their work, their appearance and their lifestyle. This may be nothing new in itself. But what is new is the degree to which artists self-consciously must cultivate their public persona and openly view it as an integral part of their work. Here are three images of the artist taken from the covers and flysheets of two recent exhibition catalogues and a monograph; each has chosen to put him or herself centre-stage in a clearly stage-managed image designed to act as a frame to their work.

Rory Carnegie posed a shirtless Damien Hirst to look like a

madman from a nineteenth-century artwork for the back flysheet of his book. Photographed in black and white through a sheet of glass, his mouth and lower nose distorted, he is rendered as being midway between a dreadful and sad victim of second-rate reconstructive surgery and a fish feeding on the side of its aquarium. By conspiring to exhibit himself in this way, the artist is clearly making reference to a successful line in his own works of art – dead animals exhibited in tanks. But as a parallel act he invites us to share his supreme self-confidence in choosing to be pictured, ironically, surrounded by bad taste as a person we should have sympathy for.

On the front cover of her 1999 Ikon Gallery show in Birmingham, Georgina Starr sits under a sparse and artificial Christmas tree listening to LPs on a Dansette record player, trying to look like someone's older sister in the 1960s. The photograph, in which a fashionable form clothes little apparent content, leaves us with the image of an artist who is marketing either the virtues of simple retro pleasure or the fun to be had from a vacuous irony.

In another Ikon Gallery exhibition catalogue, this time for a retrospective of Yinka Shonibare, the artist pictures himself as a part of one of his own artworks. Dressed in tails, he stands absorbing the adulation of a fawning group in an opulent Edwardian drawing room. As the only black face in a room full of trivial company enjoying an evening after dinner around the piano, he holds centre-stage and stares defiantly out at the viewer. The image leans heavily on the over-egged sentimentality of the very worst of Victorian painting, but possibly requires us to reflect upon our own post-colonial guilt.

A Future Portrait

What often happens when completing a painting, adding what you imagine are to be its finishing touches, is that you end up doing a complete makeover. There is no doubt that today's artists must be over eighteen years of age. There are younger people who draw and paint beautifully, but it would be a mistake to view what they do as art. The making of art is a calculated act, founded on a good under-standing of history and theory and addressed to contemporary practice and, in the first instance, to a critical audience, not a nurturing one. They will probably live in a city or spend most of their

time there. They will enjoy making things more than they enjoy looking at other artists' work, and they will never really fully understand why one piece of their work should sell and another not.

Beyond this broad definition, there are three types of artist one looks out for. The first are driven by their emotions; they are illogical and excellent bodgers, and they dive into history and pull out what they fancy without a thought for scholarship. Their artistic activities are blessed with intuitive good taste, but on the street they are likely to be mistaken for the unemployable. The second group are neat, laconic, logical, and excellent craftsmen who pay more attention to their dress. They will tend to be careful and view their work as being a continuation of the story of art. They will also have an ability to make a virtue of bad taste and boring ideas. The third group, the ones who, in my opinion, are the very best, are a subtle blend of the two.

More will be said later, but the artists of the future will not be tepid sensationalists but hot-blooded and passionate rebels from all disciplines. What they will learn is how to make their rebellious ideas concrete before an audience. They will need irony. It was more or less invisible when modern art began, but it was already sloshing around by the end of the century. Throughout art's history it has regularly crept in and out of the picture, and has played an important role in shaping the look of art. Irony works in many ways. Artists who deploy irony view art as a robust thing that should be tested to destruction; artists who don't usually view art as being like a religion which demands humility and careful nurture. The best artists are and will be those who feel able to cope with irony, becoming our most powerful and amusing visual entertainers. It has been the greatest achievement in art of the late twentieth century that irony was incorporated as an integral part of the art plot, and in such a way that neither viewer nor artist can be sure of where it begins and ends.

Note

1. Taken from Rainer Crone and Petrus Graf Schaesberg *The Secret of the Cells*, Prestel 1998.The statement was made by Louise Bourgeoise with reference to a piece of her own sculpture Title: *One and Others*. date: 1955. In *The Secret Cell* it is footnoted as, 'Louise Bourgeois, source unknown, 1997'.

2

The Work of Art
The Still Life

It has become progressively less obvious what an art student needs to learn in order to equip him or herself adequately for life as an artist. Fashion, market forces and rapid developments in the new technology of electronic image-handling caused the physically hand-built object or image to slip from pre-eminence and the projected or virtual object to replace it. While the accessibility and affordability of video, photography and their interface with computing has boomed, many of the artists who pioneered the migration to new technology have found themselves ill-equipped to personally manipulate the technology they wanted to work with because of the rapid developments. This resulted in them having to learn new skills and become like architects, dependent on planning and project management skills and the ability to purchase technical support. In this new executive role artists not only needed to find new strategies for making and funding their work but also new methods of being artists.

This deviation from the historical norm is quite unprecedented and has resulted in a reduced emphasis on traditional skills. To the artists of the past it seemed clear how it worked: standing in the studio with a canvas or block of stone before them, the subject matter beyond, art history to the left and the tools of the trade to the right. His approach came out of an empathy with materials, an understanding of how others had dealt with similar problems in the past, and the well-rehearsed practice of a craft. Through fluency, knowledge and sensitivity came invention. This is what Honoré de Balzac wrote about in *The Unknown Masterpiece*, and what De Kooning managed to materialise on the canvas in *Woman 1* (1950-52).

Digging a little deeper into the relationship between art and the hand-made, today the big divide in the way artists go about making their art is between those who need to have a totally hands-on, tactile relationship with their objects and others who are able to delegate and distance themselves from the act by using technician-controlled processes. I am not suggesting that there is now a cigar-smoking executive class of artists who project-manage their way through creativity. But artists are becoming less dependent on an approach that requires them to chip away simultaneously at an object and an idea in the studio. There are some artists who believe their sole task is to give ideas material form and others who believe that their task is to draw from materials ideas and form, but for most it is a question of following a moderate line between the two poles.

They Are What They Eat

In the first chapter I painted a picture of the modern artist. Here I want to look at the modern object by starting with the artist. Artists are not born – they come out of art. Children and young adults at some point either start or fail to notice art. Some of those who notice it become so interested that they start to try to make it for themselves. They begin by attempting to copy the appearance of an artwork they have seen and liked. A few become sufficiently involved to go to art school, and a few of these go on to work as artists. If this brief account of the lifespan of the artist is accurate, then it is clear that if art is the egg then artists are the chickens, and that it is out of the objects of art that other artists grow, not the reverse, as may at first seem logical.

Artists struggle to shape and find a position for their 'work', and as artists they are required to keep up a tireless search for new subject matter, new materials and new skills. In undertaking this quest, both artists and the presenters of art have felt obliged to resist the temptation to make too much of the fact that the search for the new is focused almost entirely on the plundering of the work of other artists, both living and dead. But to their credit there has never been an attempt to conceal it, mostly because this plundering is viewed from within the art world rather as gamblers and breeders view the

genealogy of good racehorses – as an endorsement of quality. It lends a more or less objective measure of quality, a pedigree to the work.

Today artists enjoy a much richer and fresher diet than they did in the past. Art now, like food, is faster, more plentiful, more varied, more eclectic and more cosmopolitan, and the best of it is possibly even more nourishing. At the beginning of the twentieth century art was less visible and information about what other artists were doing was much slower to travel; feeding and growth were as a result slow. Today, because of the ease with which objects and images can be moved around the world, it is very easy for both artists and their audience to become well informed about what is happening elsewhere – perhaps even over-informed.

Nonetheless the art object remains inextricably linked to subject matter as indeed it has remained the vehicle of communication with others. For the audience the subject matter comes first; it catches their attention. Then it works as the key to them reaching for the meaning. Artists are acutely aware of this. This is Van Gogh writing to his brother about trees in blossom:

> For heaven's sake send me the paints without delay. The flowering time is over so soon, and you know how this kind of subject delights everybody.

Along with blossom go fruit, animals (especially horses) and the naked human form. These kinds of subject matter have sustained the appetites of both artists and audiences throughout the history of modern figurative art. In terms of art as something whose prime function is entertainment and whose secondary use is to act as food for other artists, these subjects present themselves as ready-made meals, easy to eat and attractive forms of nourishment.

More complex are the subject matters of reductionism and abstract artists. Pollock worked with paint in a way that was so heavily identified with him and the nature of paint itself that no artist since has effectively fed from what he did. What he painted were pictures designed to be inedible to other artists. Matisse, with his paper cut-outs, and Malevich, with his white squares on a white background, both so pared down the language they were using that they also left nothing within their work for others to graze on. Although

on the surface the work of each of these three artists was highly attractive, its substance was incapable of sustaining new life.

This leaves us with the interesting proposition that some artists may set out to place themselves at the end of the food chain. There are no formal rules, but every artist is aware of the subliminal bond they must maintain with history if they are to stay in contact with an audience and continue to be recognised as artists. The ability of artists to feed from both the past and the work of other living artists is vital. The question of what is, or is not, art is seldom raised among artists. But if it is raised it will be because there is an interloper, an object or image that has broken the mould so radically that it appears to have detached itself totally from the tradition.

It is a question which is constantly posed as a consequence of modern art. When the output of artists was restricted to painting and sculpture, with perhaps a little drawing here and there, the way art was made didn't require much explaining. To the taxonomist's eye, it seemed as if art had placidly evolved into neat categories. There was a hierarchy of materials, with, for sculptors, bronze and precious metals at the top and fired clay and plaster lower down the order. Oil paint on canvas was the top of the range for painters; but watercolour and acrylics less highly valued. It is a hierarchy that ignored the Midas touch to its peril.

As modern art has evolved the range of materials that artists work with has developed almost without limit. One could list toenails, used tea bags and tampons, charcoal, fat, steel, water, ice, light, steam, meat, fire, a live parrot, a dead parrot, blood and various other body fluids. Modern art has opened the door to every conceivable material appearing on the artist's palette, and has empowered every artist to spread them. If modernism was the triumph of form and content over technique, then, in the wake of the Midas Touch, the art of the second half of the twentieth century represented the triumph of materials, process and marketing over content.

It is a period now we call post-modernism. As we have seen, modern artists have experienced a vast expansion in the range of materials, skills and technologies available to them. They are continually on the lookout for new working methods and materials, and there is no reason why this should not continue. What holds artists back is cost. Only when a new technology is developed to the point

where it can be sold on the high street can artists afford to use it. What, however, has this meant for the relationship between the material, the artist, and the subject matter?

Terry Jones of Monty Python fame called his film company Handmade Films, which I presume is an ironic reference to his relatively amateur (but ultimately caring) contribution to a multimillion-dollar industry. The term 'hand-made' can be used to signal quality but can also imply a vernacular roughness. The notion of the hand-made is so central to the activity of painting that I find it difficult to name an example where it is not a vital element of the plot. A few straight and intersecting black lines about a quarter of an inch wide, forming an erratic grid across a white canvas, with a couple of the resulting white rectangles filled in in blue, and perhaps a third in red or yellow, amount in most people's minds to a Mondrian. But what is interesting about the actual Mondrian is that it is made of paint.

The 'image' that so many people seem to recognise from reproductions they have seen in books and on record sleeves is less important. The image emerges on the canvas not as a result of a designing process but through hand-building, just like one of those Japanese tea ceremony cups where the process of creation leaves the object with tiny imperfections, mistakes that reveal traces of the decisions made during its making. This is what both the Mondrian and the teacup are about. The object would not be improved in the eyes of the maker by removing these blemishes, nor by mass production.

In all work that is hand-made and called art the viewer is invited to enjoy the evidence of its making and to explore the dialogue residual in the object between its final form and its method of making. In so doing, the viewer reflects on what creativity is, which is probably one of the higher aspirations of an engagement with art.

So the point of a Mondrian is not simply to zap the audience with a super-simple, stripped-down image of the modern, but to provide an opportunity for the audience to share with the artist the pleasure of making and inventing form. It could well be that, if there is a loss resulting from art's involvement with the keyboard and new technology, it is the loss of these traces of making and of one person's touch which is most noticeable to the viewer.

What may be said about the modern work of art, those objects artists have actually been making during the modern period? We

should consider the range in one particular genre, the still life. Only the best artists have made anything of the still life, because at their best still lives tend towards the decorative and at their worst turn out to be nothing more than celebrations of an artist's technical skill. Through this genre the best artists reveal how their Midas Touch is applied most effectively to the most prosaic subject matter.

By the beginning of the twentieth century, organising a painted still life had become more than just a matter of portraying some attractive objects on a tabletop. It demanded that the artist engage in both a more theoretical and a more poetic approach to the making. Artists began to focus not simply on describing the appearance of a bunch of things but on controlling the spaces that as a matter of course emerged between the things. Paintings became events where the things and the spaces between them were in dialogue and of equal value. Art in France was particularly rich in still lives in this period, artists there clearly realising the potential for demonstrating the power and depth of their creativity by animating and dramatising the mundane. For a while they dispensed with the need for exotic subject matter and satisfied themselves with being resurrectionists, bringing stale bread, newspapers, wood, tableware and old kitchen utensils to life.

Through such activity artists began to realise that the Midas Touch, with which they hoped they were blessed, might have more power than they originally thought. As they experimented not just with subject matter but with base materials – cardboard, boxes, plaster and found objects, rubbish from the street – it soon became clear that bronze, Carrara marble and oil paint were no longer necessary ingredients of high art. Once this was realised it also became evident that artists no longer required sophisticated craft skills to work with their materials, and that it was sufficient either to do without the hand-made (as in the case of photography or the ready-made) or use it in a more rough-and-ready creative process.

Subsequently, during the twentieth century artists gradually learned to make the most of the fact that there no longer appeared to be any restrictions on what an art object could look like. Morandi painted loosely but recognisably with oils on canvas; a few pots on a shelf emerge in the finished painting looking more like beads on a rosary than objects from a hardware store. From the middle of the

century Ed Keinholz began to build one-on-one-scale tableaux. Like nineteenth-century dioramas, his still lives were little sections of the world made from real components that were hand-built from the found and purchased, and as such probably opened the door to much of the installation art that emerged at the end of the century.

Marcel Duchamp invented the ready-made, a 'found', often mundane object appropriated by the artist and elevated in status by the act of intellectual rather than physical transformation that he or she imposes on it. *In Advance of a Broken Arm* is, for example, a snow shovel made of galvanised iron with a wooden shaft, purchased from a hardware store. It is shown leaning against a wall with its title inscribed in white paint on the back of the blade, just above the cutting edge. The original was lost in 1945; a second version was then obtained by Duchamp for a collector, and more were purchased, similarly ennobled and added to the 'edition'. The French artist Jean Hélion has a more hybrid approach. Like Morandi he continued to paint the traditional objects of still life, but his objects are made to act out moody psychodramas. Lobsters lust and baguettes throb while cigarettes are left to burn on the edges of tables – the component parts of a Provençal lunch become actors in a tabletop bodice-ripper.

John Russell, the art critic for the *New York Times*, gave poetic voice to this new canon of still life when reviewing an exhibition of Cézanne watercolours. 'Cézanne takes his repertory company of household objects – bottles, a decanter, a skull, a patterned rug, a spirit stove, seasonal fruits and kitchen essentials – and he makes them do something new every time.' Pushing this idea even farther, Russell turned his attention in the same review to a watercolour of two melons. 'Cézanne's erotic interests could come out even when they are least expected, as for instance in *The Two Melons*. What are those two melons doing, one asks oneself, if not making love?'

From these seminal works art quickly developed its new idiom. By the end of the twentieth century the cutting edge of still life was to be found in spectacle – still lives began physically to move. Chris Burden engaged the spectacle of technology. *The Flying Steamroller* (1998), 12.5 tons of yellow Navy-surplus steamroller, pursues a circular course determined by a counterbalanced beam and a pivot in the centre of the host art gallery. And Andy Warhol filmed the

Empire State Building over a period of twenty-four hours, observing not very much.

These works beg an obvious question: what does the modern artist eat? Part of the excitement of starting work on a new work of art is the anticipation of success. Before making anything concrete, most artists will have assembled the resources they expect to need during the first day of work. For a painter, as mentioned above, this will usually be a clean palette, some new paints, a bare canvas and a plan of action, before he lifts his brush. Nonetheless, there is one aspect of the task in hand which they are most unlikely to have given a moment's thought to – whether or not what they are about to make will turn out to be art. Almost certainly artists will be starting work with the assumption that it *will* so turn out. But perhaps they didn't think about it because they belong to the same group of artists as I do – those who simply don't care one way or the other. And if they *had* thought about it they would have reasoned that they are after all artists and what artists make is art.

At this point, artists divide. Some feel very strongly that the history of art is like the history of science, made up of a chain of experiments conducted by individuals and groups, each link leading to the next, while others believe passionately that as unique individuals they carry into their chosen activity particular qualities that prevent their output from being anything other than special and worthy of the status of art.

Ernst Gombrich, in his *The Story of Art*, neatly sidesteps the issue by advocating an approach that ignores what art is and tells us that it is simply what artists make, which seemingly leaves the audience with the task of finding out who the artists are and the historians and critics with the pleasure of telling them. (The Japanese clearly share Gombrich's idea and confidently designate their top artists and craftsmen as national monuments, while the UK shows more caution by reserving less laudatory titles for artists such as Royal Academician or, as the ultimate accolade, Companion of Honour.)

The artist, however, does not honour the maker of an object in the same way. It results in a lack of critical focus on the object itself – an assumption that all Picassos are good because they are by Picasso – and that once someone is designated an artist, by default all they make is art. Most people stumbling on the image of a human head or

a vase of flowers painted in oils on canvas in a junk shop would call it art. And the same would apply if they were to chance upon the full-size image of a naked man carved in white marble in the same shop.

The reason for this handsome simplification is obvious. As a culture we use rules to make sense of aspects of life that are not part of our immediate life. With regard to art, the majority are still educated to assume that the possibility of authoring something called art is not only restricted to a highly select set of names but also to an elite set of materials. If we see the right name or are confronted by one or more of the 'right' materials, those being the ones we associate with the production of art (canvas marble bronze etc) we no longer need to think critically we need to do is simply call what is before us art. Artists and dealers decide who are the artists and as a result what may be considered art. Like runners in a perpetual relay they race back and forwards in history to reinvent and bring to life those they find inspirational.

With this in mind it seems likely that the subject matter and the material from which a picture or object are made will condition the response to the significance of that image or object. If you visit a garden centre it would not be unusual to find somewhere between the shrubs and the gazebos an array of garden ornaments made from cast concrete. Most people would not mistake these objects for art, although they are clearly designed to look at least a little like art. They will not be mistaken for art because they are copies, and therefore not acceptable as art (unless presented ironically as the work of a recognised artist).

In short, they are objects that have not yet been exposed to the Midas Touch and as such enjoy the same status as the snow shovel in the hardware store prior to Duchamp buying it. In terms of the art world these are things-in-waiting. Other good examples of things no longer in waiting but appropriated for ever as art objects are the plastic lobster taken by Dali to replace the telephone receiver, the classic orange basketball taken by Jeff Koons to float submerged in a tank of salt water, Damien Hirst's stuffed shark, Duchamp's ceramic urinal, the tent appropriated by Tracey Emin, and the American flag stolen by Jasper Johns.

The governing but largely unspoken principle that all successful

artists work with is that, for an object to be designated as art, it must be recognisable as having grown out of other objects that have previously been designated as art, but be sufficiently distinct from those objects that it can be recognised as new or newish. The object must also be made not only by someone who calls himself or herself an artist but by a person recognised as such by at least one or two high achievers in the art world.

In considering what constitutes a modern art object it is crucial to remember two more easily forgotten truths, both of which are fundamental to the whole process of engaging with art. The first is simple: not everything called art is necessarily an example of excellence. The second is that the present day does not have the monopoly on challenging and outrageous objects; the history of art offers just as many examples as contemporary art. Two obvious examples are the Cerne Abbas Giant and the Etruscan Tomb of the Bulls at Tarquinia.

The Saxon chalk figure at Cerne Abbas is cut as a shallow trench into the chalk just north of Dorchester in Dorset. It must be one of the most sensational drawings ever made as public art. Stretched out across a secluded hillside pasture, the naked two-hundred-foot-tall giant brandishes a club and, by most people's yardstick, an oversized erect penis. Virtually invisible at ground level, he addresses himself to the sky. The local residents have seemingly been happy to maintain the image, and survive in its shadow without embarrassment or serious psychological damage. Records reveal that during the nineteenth century, rather than trying to destroy it, some locals, under the direction of a churchman, may even have contributed to the size of the giant's erection during an annual cleaning exercise. When mistaking his navel for the end of his penis they increased the length of the trenches describing the shaft of the penis accordingly.

Painted before the birth of Christ, the Etruscan Tomb of the Bulls obviously celebrates bulls and also, perhaps more surprisingly, buggery. In a finely painted mural decoration applied to a symmetrically hollowed-out barrel-vaulted chamber in the native tufa a few metres beneath the fields of Tarquinia, just north of Rome, a bull charges from one direction while from the other a man hiding from the beast behind a not very substantial sprig of laurel is shafted by what I take to be an acquaintance.

Unsettling the spectator has been a stock ingredient of all artists

throughout the ages – whether they were called 'artists' or not. But a consequence of the fact that ultimately it is the artists who determine who is an artist, means that the subject matter of art need not necessarily be spectacular or outrageous in a public way. While there are, of course, some who insist on presenting the raw and the epic with a view to overwhelming and shocking, for the most part artists wrestle with quite simple subjects. As art is an animal that feeds most frequently on itself rather than on pastures farther afield, it has created an almost entirely cannibalistic culture for itself. By preferring to feed in this way, artists subject themselves to a rising and falling tide through which they communicate with others and their audience in a way in which both influence what great art is.

3

The Landscape of Art
The Viewpoint

In trying to establish why the public has difficulty accepting the Now in art, and why they seem relatively unperturbed by the art of the past, one thing stands out beyond all others. The further one stands away from anything in either time or space the better it appears to spectator. The photographs of the earth taken from the Apollo space-craft represent an excellent example of this phenomenon. Certainly they reveal none of the cluttering details of natural disasters, dis-carded Coke cans or electricity pylons. What they do allow us to observe is a beautifully lit and coloured near-spherical object floating in total calm and in total darkness, with not an advertising hoarding, Range Rover or radical response to art to blot the view between us and our world. Similarly, the cool, mathematically driven minimalist American artist Carl André (1935 –) seems, with hindsight, to have become incapable of shocking us with his 1960s work executed in bricks. The first time they were shown in the UK, in the Tate Gallery in London, the tabloids thundered with comments such as 'Tate ripped off by American artist who does no more than lay out common or garden bricks on the floor.'

Today the standard response is disinterest. While flicking through some more recent newspapers, the *News of the World* on 24 October 1999, the day the Turner Prize winner was announced, focused on the demise of a couple of Casanovas, one cad, one bounder and the hair colour of Michael Jackson's son. There was not a mention of the Turner Prize or Tracey Emin's *My Bed*, which had just gone on show at the Tate. The serious press, however, could still not contain their mixture of scorn and admiration for the Turner Prize's front-running

nominee, and ran reviews that could have appeared in the news sections.

A large unmade bed surrounded by the detritus of one of the artist's lost weekends (or perhaps it is just an average weekend) was pictured in the newspapers. Dirty sheets, vodka bottles, soiled knickers and used condoms frame the bed in the expectation of accumulating meaning, and to assist in producing yet another film-still image from the encyclopaedia of the abject, a reference work that became particularly useful during the last twenty years of the twentieth century. Art critics framed her object with an array of words. 'Her strewn things sum up the look of the time we live in,' said Matthew Collings in the *Independent on Sunday*. On the other side of the bed, so to speak, John McEwen in the *Sunday Telegraph* reminded us that this wasn't simply art and that the emotions the artist had set before us were real. But he then asked, 'Her sob story may be sad, but what makes her think it will interest the rest of us?'

Whether or not we are interested in the object – in fact, similar creations, dirty sheets and condoms had already established themselves as frequent visitors to the art scene and it was another predictable choice coming from the Tate – it does beg an important question. What influence has the supporting cast that populates the art world has on art? How do art galleries and museums and their buildings form part of its landscape? They like the rest of its audience have to engage with the Now in art, however troublesome this may be.

The Landscape

The first landscapes were designed simply to be that part of a painting called the background – to act as backdrops to more important activities. These first landscapes seldom amounted to much more than the green, blue and brown bits that filled the gaps in paintings between the humans, their animals and their homes, and in doing so indicated the outdoors. In Roman painting landscapes were a popular component of mural decoration because they had the ability to spirit away the wall, and in doing so furnish an interior space with the illusion of fresh air, sunshine and views of a safe, idealised beauty beyond.

3. The Landscape of Art

Today a landscape can no longer be adequately described just in terms of its apparent topographical, geological or even psychological shape. A description of any landscape also needs to take into account its political, sociological and economic topography. The biggest decision a landscape painter makes when he or she starts a new work is about whether to paint directly from the subject or to take notes and then try to reinvent the subject back in the studio. For artists, the decision as to where to stand in relation to their subject, although sometimes conditioned by physical circumstances, is more often determined by their attitude towards what they see as truth. They tend to feel either that they need to be at the coalface, working from the real thing and grabbing the essence of their subject by literally being on top of it, or that a more distanced approach is appropriate – the latter being one that depends on assembling the evidence, on sifting facts, back in the studio. They lead to two very different outlooks.

Working 'before' the subject, as Van Gogh did, is quite a different thing from reconstructing an 'after' image of the subject in the studio from records, notes and memories, as perhaps Mondrian did. In a letter to his brother Theo, Van Gogh describes the process of painting a picture.

It is true that I have retouched the whole to rearrange the composition a bit, and to make the touch harmonious, but all the essential work was done in a single long sitting, and I change them as little as possible when I am retouching.

This letter reveals a trace of guilt, possibly brought on by his having mixed the 'before' and the 'after' during the making.

Most writers on art value and make a virtue of the pure, and of a tough, unilateral approach; few have anything to say about the hybrid, which I believe, if you look closely, most good modern art turns out to be. In August 1845 the art critic John Ruskin visited Switzerland, in the footsteps of J.M.W. Turner, in order to find the places the latter had drawn a year of two before. He discovered to his surprise that his hero hadn't faithfully recorded the St Gotthard pass, as it ran down into Italy near Faido, but had instead exercised artistic licence. Once Ruskin had recovered from what we are told was a considerable shock, he appears rather to have taken to the idea

that a landscape drawing could be something more than a strict topographical record. In stark contrast with Turner's image, the landscapes of modern art tend to picture a world where the view is either urban, suburban or industrial. These images remind us of the work of man rather than raw nature itself.

The landscape of art is constructed from these two poles, with some artists leaning towards nature and perhaps a god, and others towards the artificial and the man-made. It is a more complex and less familiar image than the view from my studio window and it has become considerably more inventive than even Ruskin could have imagined when, in order to legitimise a modern and hybrid approach that blended invention and observation, he invested it with a para-scientific authority and coined the phrase 'The Turnerian Topography'.

Today's Landscape

All artists are to some extent landscape painters. Not because they work directly from the exterior world, but because everything they make which sets out to be art will as a matter of course have its appearance conditioned by the shape of the landscape of art at the time of its making. This is the case because whatever else artists feed on they must also feed on the landscape itself. The landscape of modern art exists as two interlocking and interdependent topographies, which may be called 'A' and 'B'. Together they make up a landscape that has grown gradually to encompass the earth. 'A' is totally urban and consists of a series of colonised peaks and more sparsely developed troughs; to picture it visualise a model of a north/south diagrammatic section through the Andes. Landscape 'B' is almost virtual, and is probably best thought of as a floating substance of written and spoken information that wraps itself around and thickens between each peak of landscape 'A', like a cloud, obscuring the view from peak to valley while providing the lower part of the view from peak to peak.

The population of the art world moves quite freely between the peaks of the art world ('A') and its glaciers of information ('B'). But outsiders have traditionally found both landscapes not only inaccessible but more or less invisible, fading far away into the background.

Except for the occasional journalist visiting exalted museums and exhibitions, there isn't much direct or indirect contact. Generally artists have played it safe and restricted their activities to venues that are clearly a part of the art world. There are signs, however, that the border is beginning to erode. Some artists today work in the 'real' world, even if they are mostly rebels who have turned their backs on the exhibiting possibilities of the art world.

A notable genre in which this happens is Land Art, which is made by artists who set out to use the landscape both as a surface and a backdrop to their invention. Other artists have chosen the commercial and urban environment as a suitable showing space. One unusual example of this occurs in Japan, where the thoroughly post-modern idea of a serious art gallery existing within a department store is a common occurrence.

This erosion, the breaking down of the barrier between high and low culture, is something that has been encouraged by post-modernism and the globalisation of art. An example of the latter is the developing field of folk art, where exhibitions of ethnic arts and crafts have begun to infiltrate the high-art gallery circuit. The influence of post-modernism is exemplified in the work of Jeff Koons, who rehabilitates tourist souvenir junk by recasting it on a large scale or in precious metals and places it before a gallery-going audience. Despite all this, a deep-rooted conservatism among artists has resulted in even the most apparently radical practitioners continuing to expect to exhibit in old-style museums and galleries, because of the status it confers.

Although there is some evidence to suggest that Jilly Cooper was right when she described the art scene today as being like the pop music business, artists and dealers haven't yet worked out a way of stacking their art high and selling it cheap. In the UK art supermarkets start, soar and fail. Art dealers have, however, got some of the way there by establishing the basis of a mass audience. Unfortunately, though, the market is still confined to luxury goods, and as a result struggling to do something equivalent to selling the contents of the Harrods food hall to readers of the *Big Issue*. But if art is to escape the final shackles of its past, this development needs to materialise sooner rather than later.

Landscape 'A'

Landscape 'A' is a chain of urban environments, each with its own art schools, artists' studios, museums, galleries, auction and collectors' houses, and is dotted across the real world. An élite group of museum directors, owners of commercial galleries and heads of art schools (who from time to time invite artists, big-hitting collectors, critics and industrialists to assist them) control the landscape of 'A'. The population on each peak is made up entirely of artists, teachers of art, gallery assistants, technicians and collectors. The urban plan of each art centre is a series of concentric rings connected by radial links. The most important buildings, the national museums, are at the centre, and around them is an inner ring of commercial galleries and smaller public collections. Beyond these are the art schools and small public venues, with the down-market galleries in a more outward ring.

As we move out from the centre, the formality of the city plan diminishes as we approach the artists' studios and alternative galleries. For the inhabitants of the lower slopes and valley bottoms, existence beneath the obscuring shroud of landscape 'B' is tough as, although in theory they are still part of the urban landscape of art, they are in reality looked upon by the inhabitants of the higher slopes and peaks as not really being part of the scene, and as such are more or less ignored.

Two conceptual webs, one called private enterprise, the other state subsidy, overlie the part of the landscape occupied by the galleries, and establish two types of exhibiting opportunity for the artists. Because it is the sole objective of any artist to achieve within a lifetime as many exhibitions within quality institutions or dealerships as possible, the points of contact within these webs between elements of the human, physical and economic geographies can be highly charged.

Exhibitions are either 'group' or 'one-person', and are held in galleries that are either private- or state-funded. As a rule artists first emerge into public view as a result of exposure through group shows, in either the state- or the private-sector galleries. A second stage of recognition follows which usually results in a desire on the part of the artist to grab either extra kudos or cash, depending on what was in short supply during their first outing, by defecting to the

other gallery sector. Successful artists usually end up moving freely between the two webs, having realised that they intermesh and that at the very top more or less the same people control both. This enables some modern artists to be both rich and respected.

Crucial to the landscape are the galleries and museums, and their shift in presentation. At the start of the twentieth century these buildings, if they were not commercial, were housed in converted palaces, either custom-built or no longer required for residential use. By the turn of the century they are being housed in converted factories (the Custard Factory, Birmingham), warehouses (the Tate, Liverpool), railway (Musée d'Orsay, Paris) and power stations (the Bankside Tate, London), buildings that no longer have any industrial value and are sited just out of the centre.

During the same period the decor and detailing of their interiors changed. To turn a palace into a museum or gallery is a fairly simple business – all that was needed was to remove most of the furniture and mirrors and all the rugs and carpets. The shutters are then simply thrown open and the transformation is more or less complete. For factories and power stations a little more work is required – the removal of the plant, the construction of internal walls, the application of gallons of mainly white paint and the installation of state-of-the-art lighting. Out of this later type and style of conversion grew the modern gallery, the white cube, as it has become known. Like Tipp-Ex, it came from the culture of obliteration, becoming the preferred environment for exhibiting art.

Both artists and curators wanted an empty, featureless, clean white space with no windows, radiators or dado rail. They sought an environment where art could float in the nearest thing to the ether – a virtual environment. As time went on and production values rose, gallery walls became even whiter and even smoother, new lighting and environmental controls were installed, and on-site catering moved up-market from a cup of tea to a glass of Chardonnay, and from a sandwich to something vegetable in filo pastry.

One problem did, however, emerge, heralding the shift in focus we experience today. Artists had begun to change the shape and priorities of their work. This change in their approach to art resulted in artists also changing the physical demands they made on galleries. Feeding on new ideas, not only from the history of their own disci-

pline but from other areas of the entertainment industry. In their search for a richer and more varied diet they turned to film, television, video, theatre – even the circus and the zoo. Unfortunately art impresarios didn't have much experience of working with moving images and sound, let alone animals and seated audiences. Change was forced on galleries, which were obliged to reconsider their role in the presentation of art.

It meant that a new conflict of interests had arisen, one with curators over the cost and logistics of realising an installation or project in the white cube, clearly an ill-adapted environment to anything but a two-dimensional painting. Mounting an exhibition of art was no longer a question of banging a nail into a wall or installing a plinth to stand an object on. Art galleries are being forced to become more like laboratories than airy display spaces – laboratories where a wide range of experiments can take place and be observed. A simple white room is no longer adequate; artists needed banks of audiovisual equipment, an infinitely flexible interior space, and simultaneously total darkness and bright daylight. One artist was irritated to find that the gallery where work was due to be exhibited was not prepared to move a lift shaft – the core of the recently converted building – to allow a more satisfactory installation of their work.

In short artists wanted the earth.

Not surprisingly, perceptive gallery directors have begun to realise that they must learn to embrace more complex technology. And in museums, curators are being sent on training courses to emerge as highly skilled technicians, able to cope with the installation of a new generation of exhibitions. At the time of writing the new Museum of Modern Art at Bankside in London has yet to open, but it will no doubt be a useful barometer of the pressure in today's climate.

In commercial galleries, the transition is having a much more invasive effect. Throughout the history of modern art commercial galleries have continued to trade at ground-floor level with windows looking onto the high street (if they can afford it), clustering in ghettoes for the convenience of their shared customers as commercial galleries seldom rely on the passing trade of window-shoppers. They are normally cornershop-sized and designed in a style that echoes the domestic tastes of the day. Today they feature stripped-pine floors;

in the fifties it was wallpaper and carpets. Presumably this emphasis
on decor is intended to give purchasers an idea of what the object will
look like when they get it home, as well as to indicate what good taste
is all about – a primary goal. One thing commercial galleries are all
used to is that most people who enter their premises have no inten-
tion of making a purchase, so they are much more than a retail outlet
– they are also a valuable addition to the state-organised museum
sector.

The greatest change in landscape has been reserved for the artists'
studio. By the 1970s all serious artists in London had ceased to view
the purpose-built studio in Chelsea, Hampstead or Holland Park as
a realistic or even a worthwhile element of setting up shop as an
artist – property prices were simply too high. Most artists moved into
studios in the converted inner city or Docklands in search of more
space, more fun and cheaper rents. Some of their older and more
successful colleagues shunned the reconstructed inner city, but none-
theless all went for bigger.

As well as bigger, everything became simpler. Studios became
cleaner places and began to resemble the white cubes the artists
hoped to show in. Doors were flush and no longer panelled, architec-
tural features were smothered in layers of white emulsion paint, and
windows were covered with white blinds. Studios became places
where buyers viewed the product and came away with little idea of
how the art was actually made. The studio became a showroom and
ceased to be a workshop. Furthermore, by the early 1990s painting
was not exactly dead but very unfashionable. Just about all success-
ful new art was installation-based or featured time as an operative
dimension (performance, film or video). Few artists other than the
old, well established and daft bothered with studios and the business
of speculatively working on an object.

Such studios as there are now, sport desks and filing cabinets and,
like corporate headquarters, have become spaces for making presen-
tations, planning strategies, holding parties and endorsing lifestyles.
They are certainly not for the manufacture of a work of art. Most
artists under thirty make lens- or time-based installation work,
which enable them to return to their front rooms and, rather than sit
in the wilderness of their studio making art they hoped someone

would like, dream up projects with which they hoped to hook funders and curators.

Economically this situation has removed all risks and overheads from the artist, who has taken on a role more analogous to acting than to inventing. They, like a good brand, need to be able to manage and be managed. When Damien Hirst is persuaded to exhibit at the Royal Academy it is not simply for the appearance of his work that the invitation is extended, but also on account of his name's box office pulling power. Like theatre and film, now gallery directors have a need for big names – you need a Leonardo diCaprio to sell your exhibitions.

Thus, galleries in their new pro-active and commissioning role have found a more creative place for themselves in the art world. Curators have lost their passive, caring image and instead adopted a more aggressive stance. It is an invigorating change in the landscape which artists have neatly cashed in on the galleries' hunger for new art and big names by convincing them to fund progressively more spectacular and outrageous projects.

Landscape 'B'

This landscape is far more amorphous. It is a floating mass, composed almost entirely of printed and digital information, stratified through time. It is perhaps best imagined as a cross between a Mexican wave and a sculpture by David Mac, who constructs his art from thousands of periodicals. If you penetrate deeply into this mass of information about British art you will ultimately find Vasari's *Lives of the Most Eminent Painters, Sculptors and Architects*, the *Codex Mendosa* describing the European conquest of Mexico, and copies of essays by John Ruskin.

Through the mass, however, there are unread books about artists we have never heard of. Catalogues of exhibitions that a mere hundred people saw, films and videos of artists' lives, digital images and 35mm slides of paintings, whole websites set up with which art schools and museums are littered, recent deposits of the art world. Like erratic glacial rocks accumulating layer by layer, each year the pack gets thicker under the art world's obsession with information.

Editors, gallery directors and publishers control this landscape.

Successful artists strut across it, while the less successful yearn to be able to do so. Its population is made up of critics, writers on art, art historians, printers, designers and photographers, all of whom record and comment on the activities taking place in the physical art world of Landscape 'A'. The artist population of 'A' take notice of their work and study their output as primitives watched the stars.

Access to 'B' though complex is crucial, and every artist must be aware of its functioning. Parts can be reached very easily and by anyone through high-street bookshops, but for a fuller picture specialist libraries and the Internet are the only way in. There are also large tracts that can only be reached by joining a mailing list; these lists, compiled and distributed by galleries, publishers and arts funding agencies, are the primary forces in generating the topography. If you succeed in getting your name onto a list or two – or have been unable to avoid the privilege – every morning your doormat will serve as a reminder of what the margins between the landscapes of 'A' and 'B' look like.

Although the late eighteenth and nineteenth centuries made their contributions, the strata laid down during the twentieth century have without doubt produced the bulk of the topography. At its depths the geology of 'B' is composed almost entirely of black ink on white paper, with colour gradually emerging as we near the surface and the present day. The early levels, although significant at the time, now appear as nothing more than a slim grey silt, with the occasional major work jutting out. The surface deposits are the most wide ranging, but the bulk is made up of books, exhibition catalogues, video and films.

Picture books, the most popular publications about art, aim to show, within the limits of technology and the 'reader's' imagination, what art looks like, and as a result can be used by anyone, although users cannot necessarily make sense of them. Text-based books about art that concentrate on its history and theories are written for the specialist reader and the library shelf. These books offer a lot of useful information for essay writers and provide both pieces and adhesive for scholarly jigsaw puzzles. Another type of book blends text and pictures and tries to cover a middle ground. These books set out to present a way of looking at art geared towards its demystifica-

tion, and do not aim to show you what modern art looks like, although sometimes they tell you why it looks that way.

Perhaps the most important type of publication is the catalogue. These are published to accompany exhibitions, and usually contain a list of works, images of the art, a biography of the artist, and an essay by a critic or art historian. Published as paperbacks or pamphlets by art galleries, and sometimes by more conventional publishers, they have become the single most important mechanism for disseminating information about galleries, artists and their work. Good distribution and high-quality colour reproduction have more or less removed the need to actually attend exhibitions.

Catalogues have a complex trading value, somewhere between free, priceless and worthless. They are variously treated as library books or ephemera for the bin. Many occupy a similar niche in their respective marketplace to the facsimile shirts that football clubs sell to their fans do in theirs. Both are equally cynical, exploitative marketing tools, their emptiness directly proportional to the distance the purchaser stands from the real thing. Nonetheless, for artists they are a kind of currency, as in theory they add value to their status. In large galleries, for popular shows the catalogue can be an important part of the merchandising; with big audiences and big print-runs big profits can be made.

At the 1999 Monet exhibition at the Royal Academy of Arts in London about 135,000 catalogues were sold. In public galleries the most crowded room is usually the shop where they sell the postcards. These provide the cheapest and most convenient means of experiencing the images of art at home. They are also the most inexpensive mementoes available. Pinned to notice-boards or propped on shelves, they are records of what we consider current, of interest, shocking or beautiful. The same Monet exhibition at the RA sold 650,000 postcards and 14,000 calendars during its three-month life.

Art magazines are full of advertisements and reviews of exhibitions that most readers will never visit. Some are lucky and end up bound in art school libraries to be consulted by students writing essays. Others go to arts funding agencies and galleries to be consulted by the selectors of exhibitions. The best – *Art Monthly*, *Art in America*, *Frieze*, *Art Forum* and *Flash Art* – give a fairly clear and accurate idea of what is going on in the art world and keep the reader

well informed, without them needing to set foot in the actual terrain of the art world.

Inevitably technology has changed the landscape here too. Videos are a 1980s and 1990s phenomenon. There is a performance art magazine called *Grey Suit* which is distributed as a videocassette; there are also endless promotional videos for artists and art projects, a format that is unlikely to survive beyond 2005, because in the end all such material will be available on the Internet, or whatever succeeds it. Art films divide into two types: pedagogical documentaries and biographies. While the former sometimes turn out to be important records and provide an opportunity for the viewer to make their own judgements on, for example, the personality of Picasso, biographies tend towards cliché – try the previously mentioned *Lust for Life*, starring Kirk Douglas, for size.

The most recent layer of deposit is the website, increasingly popular as a high quality but relatively inexpensive means of advertising and publishing the work of artists and galleries. A recent example is an on-line art magazine edited by Sasha Craddock, found at www.londonart.co.uk. To date web publishing has failed to reduce the volume of paper produced by the art world. In fact, ironically, it has probably doubled it as art presenters tend to advertise their activities on the web by sending out postal mailshots.

The Psychology of Art and the Landscape

The libraries of most art schools avoid the Dewey decimal system of classification; instead they stack their books by artist's name in alphabetical order, subdivided by country and century. What is interesting when you study the shelves of one of these art school libraries is how few artists in the twentieth century move country (or, in terms of my model, swap peaks).

It is true that Picasso was Spanish and is now possibly thought of as French, but for how many other artists in the twentieth century, other than those forced to relocate by war, is this true? Marcel Duchamp was still French, in spite of the fact that he spent the latter part of his career in the USA. Is this also the case with Beckmann and Chagal? About twenty years ago David Hockney, who is perhaps still the best-known living British painter, gave up England for the

warmth of California, but today most people continue to think of him as a British artist. The British painter John Walker similarly relocated to the USA, leaving Britain wounded by the harsh criticism attracted by his Hayward Gallery retrospective. He was followed some ten years later by R.B. Kitaj – a North American graduate of the Ruskin School in Oxford, who, after a period as a GI, had found it conducive to settle in London, until the critical response to his 1996 Tate retrospective caused him to return to the States. In spite of these examples, most artists appear not to relocate and plod on in their country of origin, their reputation and work being internationally disseminated through parallel activity in the virtual landscape of art.

A common pattern is for perfectly happy and successful young British artists to get angry later in life. Consumed, it seems, by a lack of endorsement, and a lack of sunshine, and with no effective means of channelling their emotions constructively into their studio activities, they take to writing as a hobby.

Art schools are at the very centre of the art world, as they are after all its bedrock. All art schools set out to teach the skills they believe are required to shape the artists of the future. But especially when the art market is buoyant, they should avoid devoting too much time to encouraging students to reflect the current marketplace in their studio work. The art of the day is a vivid model that is all too easily copied. If art schools want to produce graduates who really are artists, it is counterproductive for them to set out to shape young people for a market that already exists. Artists are people who determine their own subject matter, and in doing so define their own product. They should not allow themselves to be shaped by market forces, collectors and funding agencies – that is unless they want to go all the way down the road towards becoming visual entertainers.

But where some art schools fail is that they overlook one aspect of art, in favour of the safety of relying on methods of the past, observing the letter but not the spirit of art. Art schools need to educate artists to call the shots, not to follow the crowd. They need to establish the difference between invention and the equivalent in the visual arts of method acting, and explore the intellectual space between freedom on the one hand and product development on the other.

From his Eagle's Nest in Zennor, the painter Patrick Heron kept

a close eye on art schools and sustained a tireless campaign of letter-writing, aimed at preventing them losing their independence. He wanted to keep them out of universities and polytechnics and guard against them having to impose matriculation requirements. In addition, he sought to stop their drift away from employing 'world-famous artists' as teachers and prevent them becoming 'faculties' of art, which he saw as being under the thumb of a polytechnic director he characterised as 'an obscure physicist, chemist or engineer turned administrator'.

Today I think we can be fairly certain that Heron's campaign failed almost totally and on each count. There are very few art schools left that aren't part of a former polytechnic, old or new university, or a larger institution. Most fine art departments impose matriculation requirements, and few world-famous artists now teach in British art schools. Unlike John Ruskin and Felix Slade, who founded the art schools that bear their names, Patrick Heron clearly saw art as being better served outside universities.

Heron's dilution theory may be correct, and universities may not be fit places for artists to work, let alone carry out research. If, however, it is invalid, why did the man Sir Nicholas Serota described as 'one of the most influential figures in postwar British art' get it so wrong? The answer may be quite simple. Perhaps there are now two kinds of involvement with the visual arts – the kind that Jilly Cooper wants to write about, and the kind I work with.

Once they are successful and the cash starts to flow in from the private sector, there is no doubt that British artists – unlike their successful equivalents in medicine, mathematics or philosophy – tend to stop working within the academic sphere. This bailing-out leaves universities that offer fine art courses with the 'art royalty' cleanly cut from the top of the pack, and as a result at a disadvantage compared to other disciplines, which have their elder statesmen and women stacked up in chairs and research posts, bringing kudos, research power and grants to their respective subjects.

Artists tend to work 'from home', having chosen not to establish the foothold that other academic staff have as researchers in universities. Most, in spite of financial instability, prefer the freedom of self-employed status to cloistered academia. By operating as small businesses or sole traders, they enjoy a certain amount of tax relief.

The reason for all this, I suspect, is that the rewards for artists working commercially outside higher education can be substantial, and most would-be artists have been prepared to risk all, at least for a while, in pursuit of a commercial holy grail. I also surmise that as a result of a government decision in the 1980s, which aimed to place a greater emphasis within the universities' funding methodology on research, universities are reassessing their relationship with the commercial art world and artists are reassessing their relationship with the landscape in which they are bred and sustained.

Whatever the reason, it is clearly wrong. If even the music and theatre world reaches out to its young artists, today's successful artists should make at least the same effort. What interests me most about Slade and Ruskin is their genuine, perhaps even crazy, involvement with the subject they supported. Both backed up their benefaction with a philosophy aimed at improving the status and economy of art, as well as the depth of artists' education. In short they recognised the degree to which a study of fine art could benefit from the nurture of a caring university and the student's removal from the marketplace

There were, and are still, considerable opportunities for artists to work and for dealers to trade in a marketplace independent of higher education. There is, however, less evidence to suggest that the training of artists will ever be improved by establishing itself free of this sector, or that practitioners such as David Hockney or R. B. Kitaj would have emerged on the scene without ever having gone to art school. Developments in the range and power of new technologies with which artists are now increasingly working, and the high production values that both artists and their audience seem to require today, mean that in future fewer artists will have the funding or facilities to work from home.

Like scientists, in order to gain access to the equipment and technical support they require, artists in the future will need to work either with industrial facilities on commercially funded projects (as, for example, film-makers have done for the last ninety years) or in a university. What appears to have made Patrick Heron nervous about this latter scenario was the notion of his private dream as an artist being stifled by the larger intellectual concerns of a university, which he clearly thought had nothing to do with art. To protect himself

against accusations of parochialism, he fired at the easy target and aimed his missiles at bureaucracy – which, as anyone who has worked in the higher education sector will tell you, is the least of our problems. At a personal level he seemed to think that by living in glorious physical isolation his art would remain pure and presumably become better. The failure of his mission is, in my view, a good thing, as I believe we have some way to go before the full benefits of the underpinning principles of Slade and Ruskin's benefactions are realised.

4

The Exhibition
Collectors and Frames

One way of looking at interiors both within and beyond art is as a metaphor for the mind. Walk into the average sixteen-year-old's bedroom and you get a rough idea of the obsessions that currently plague them. Some of the evidence will be plastered as a clear statement of intent to the walls, some carefully placed like a massive still life on every conceivable horizontal surface, and the rest scattered about carelessly. Beneath the obvious 'this is my space and I do not wish it to be confused with your space' message, which is aimed directly at the parent, is another, more complex message which concerns itself with display and a sense of order. In the grown-up world empty cigarette packets, discarded clothing, half-drunk cups of tea and the half-used bottles of every cosmetic known to man soon lose their charm as decor. For the recent recruit they represent the chosen environment.

By way of contrast, if you visit the home of an established art dealer it is usually very neat. From time to time it may fall into mild disarray, but unlike the teenager's bedroom it is easily tidied. The teenager's bedroom cannot be cleaned and tidied and still maintain its integrity – to tidy is to trash, so like a painting by De Kooning it cannot be improved by stripping out what appears to be unnecessary, cleaning up the edges and getting rid of the drips. At the dealer's house just as much care will have gone into selecting the objects and their position – usually fine examples of the modern blended with fine examples from the past. A pre-Columbian pot will sit on a piece of modern furniture by Fred Baier; a print by Miró will hang over an eighteenth-century carved wooden bed from Spain. There will be a

couple of major statements – a large painting as you enter or a life-size sculpture in the window bay, then a trail of fine pieces dotted throughout the space.

What the art dealer's home sets out to achieve in the broadest terms is a statement identical to the sixteen-year-old's: 'This is my space and it is not to be confused with anyone else's space.' The difference, however, occurs during the making of the space and in the editing. The art dealer carefully selects and places everything to send out the message 'I want you to enjoy being in this space and being with these things and once this is achieved you will begin to understand the significance of my choice'. While the sixteen-year-old is saying, 'I bet you can't live with this lot for very long. Don't stay.' For art it is very important to figure out what makes the viewer 'stay' and pay attention.

The Place

In art where the ideas come from does provide part of the 'frame' and can condition our understanding of the work. The image of art, the reproduction of a Gilbert and George work on the label of a Beck's beer bottle, or that greenish-grey photo of a preserved shark which you might stumble across in a copy of *The Face* or *Loaded*, doesn't achieve this. The bottle can be left on a shelf and the shark cut out and pinned to a door. But in contrast to the real thing, there is nothing much to look at. The image of art can certainly remind you of what it represents and on some occasions communicate the idea of the object to the viewer, but it never carries the same message or viewing-experience as the real thing.

It is essential, therefore, to look at how art is packaged and presented by the modern art dealer and wonder whether one is in fact asked to 'stay'. And the picture one may paint includes not only the art gallery and the picture frame, but also takes in the scene of the modern artist one describes. Although a particular location can be described as an interior, interiors don't exist without people. If at times they appear to be absent from the scene it will be because they and those around them have either just walked out or are about to return.

If you read about the New York School, the painters and sculptors

who worked in New York in the middle of the twentieth century, you soon realise that the success of these artists was based as much on their way of life, where they lived and the packaging of their work as it was on the quality of their output or the value of their contribution to the story of art. Jackson Pollock was the most famous because his painting, commitment and drinking were all harder than anyone else's. His approach and reputation clearly inspired young painters and impressed collectors. Like the circus performer's act, his was all about taking risks and making it work. Artist Robert Goodenough describes Pollock at home in East Hampton, Long Island, in 1951.

> To enter Pollock's studio is to enter another world, a place where the intensity of the artist's mind and feelings are given full play ... At one end of the barn the floor is literally covered with large cans of enamel, aluminium and tube colours – the boards that do show are covered with paint drippings. Nearby a skull rests on a chest of drawers. Three or four cans contain stubby paintbrushes of various sizes. About the rest of the studio, on the floor and walls, are paintings in various stages of completion, many of enormous proportions. Here Pollock often sits for hours in deep contemplation of work in progress, his face forming rigid lines and often settling into a heavy frown. A Pollock painting is not born easily but comes into being after weeks, often months of work and thought. At times he paints with feverish activity, or again with slow deliberation.

What is clear from Goodenough's description is that Pollock was seen by at least some as a very special person, but by others, who clearly included fellow artist Larry Rivers, he was regarded as a self-centred drunk. In 1954 Rivers summed up his view of Pollock when he referred to 'the mindless impossibility of his work', while other critics simply dubbed him 'Jack the Dripper'.

Pollock championed modernity. But contrast him with De Kooning, another quintessential twentieth-century artist, who championed tradition. He was part of the same art scene. Both produced powerful, cutting-edge work. Pollock died young in a car crash, De Kooning went on to old age and Alzheimer's disease. Nonetheless, the essential

differences between them centre on one question – where does art come from? Pollock saw it as coming out of himself and De Kooning out of history, yet both clearly believed in the power of the individual and understood the value of maintaining a charismatic social position. They both lived in a particular city, New York, at a time when it was the centre of the global art world.

What is interesting about the particular set of circumstances that allowed New York to become the centre of the art world after World War II is that it wasn't based so much on a shared aesthetic among artists, dealers and collectors as a belief in the power of the individual and a shared desire to make America work. It didn't matter that Pollock was coming at subject matter, source and influence from a different angle to De Kooning; what was important was that they both worked in the same town, performed in the same bars, galleries, newspapers and art schools, and before more or less the same audience. They saw themselves, like Picasso and Braque, as explorers, and were packaged by the marketplace accordingly. In the end I doubt if their differences were of very much interest to the art market. What is more likely is that the audience enjoyed the resulting dialectic, which in turn stimulated the market rather than damaging it. Art needs a buzz to thrive. It cannot exist in quiet contemplation.

The Exhibition

As a phenomenon, the exhibition is intimately tied up with the origin of modern art. Until the French Royal Academy changed its statutes in the mid-seventeenth century and required members to exhibit in a biannual exhibition, there was no such thing as a public exhibition of art or Academician's art. Although many Academicians felt obliged to exhibit, they were concerned that doing so gave the impression that they were offering goods for sale and hence reduced them as artists to the level of market traders. But by the mid-eighteenth century the annual exhibition or 'salon' was firmly established and artists had become used to the idea of producing work for an exhibition and as a way to communicate with their audience. By the end of the century this change in the relationship between artists and their audience and the artefact and the public was firmly in place, bol-

stered by the establishment, at about the same time, of the public museum and gallery.

With public access came the empowerment of the public and, more importantly, their critical response. When art was the product of a contract between artist and patron the relationship between artist and audience was mediated through the taste and influence of the patron. It was a fairly 'safe' and relatively private relationship for both parties. With the exhibition (whether or not behind the protective buffer of the Academy) artists were for the first time meeting their audience face to face and sometimes head-on. Their work was on display, before a purchase was made and the work had implicitly received the imprimatur of the wealthy and supposedly knowledgeable patron.

The new audience was unvetted, unfettered and to some extent unknown, presenting artists with a new problem – how could they negotiate with unknown people? How could they please an audience they could not recognise? It is unthinkable today that an artist managed to narrow his or her target audience to simply one man or woman as he could have previously with a member of the Medici family. Moreover, by participating in 'the exhibition' artists publicly threw themselves into competition with each other. Although there was nothing new in this, competition had never been so formal or so out and public before.

The ambitious artists' response was a brilliant piece of marketing. They embraced competition openly and as a result the 'Exhibition Piece' was born, still a firm model for all modern art. Artists set out to produce paintings like *The Raft of the Medusa* or *The Death of Nelson*, which made Benjamin West the Steven Spielberg of his day. Artists and entrepreneurs began to construct an aggressive commercial environment around the exhibition, which focused on developing and possibly exploiting the potential of a new audience. Paintings such as *The Raft of the Medusa* were toured like films on general release; entrance fees were charged; spin-off publications, both catalogues and reproductions, were printed and sold, bringing cash rewards to artist, investors, printers and publishers.

In this new climate, the press inevitably became an essential part in connecting art with audience; apart from advertising exhibitions and swelling attendance figures. They also contributed to public

interest and excitement by reporting on art as a newsworthy event in the world, initially as part of tattle about the great and the good but today more about the what the artist is himself. Artists and investors quickly grasped the commercial potential of this, which resulted in several successful hits. Nathaniel Hone's painting *The Conjurer* may not at first sight appear to offer a publicist much scope for tabloid spin, but when the artist revealed to the press that a close female friend of the President of the Royal Academy in London had modelled nude to assist in the making of the painting, and that this had been the reason for its exclusion from the summer show, it hit the spot. The successful one-man, one-painting show was born. Galleries further influenced the relationship between the viewer and art. They are not designed as places of study or even pleasure.

Galleries are places where a sale is made or at any rate facilitated. Where previously the patron decided what he wanted to have in his own mind, the gallery suggested to him what he might like to carry away there and then. And this has created one of the major fault lines in modern art. Art was always intended to be sat with, whether in churches, big homes or today's functional homes. Paintings are made to be lived with so that what they have to offer slowly unfolds. They are temporal, like film. It is something which modern galleries seem to have lost sight of over the past thirty years. By taking the seats out of galleries in the fifties, the art industry relegated its 'product' completely to the flow-space, as something to fasten the eye on while circulating the gallery. The creation of this peripatic environment for the buyer is most peculiar. If libraries had no seats or desks it would be irritating to scholars, though the photocopier and the Internet have enabled them to read at home and in the office. But there is no such technology available to readers of paintings; we may not take them home to be propped on the mantelpiece and studied for a week or two.

The inner workings of the art gallery are no less alienating. It is odd how commercial art galleries have decided to organise their retail activities. Each time a gallery features an artist, it tends to concentrate on recent work. It will print an invitation card, organise an opening party, take out an advertisement in the trade press, and possibly produce a catalogue, then sit back and see if anyone reviews or comes to see the show, or buys the artwork. What they do eight or

ten times a year, every year, is feature an artist of the month. From a retailer's perspective, this is like filling your shop with beans in June, then spring onions in July and sprouts in November, with just a few other vegetables in a back room available for purchase if customers know they are there and have the confidence to ask for them.

Whatever happens, within a year the show is generally forgotten – the unsold catalogues remain in boxes in the cellar and the art is either returned to the artist's studio or distributed to the homes and collections of buyers. From the artist's viewpoint, the anticipation of the exhibition is always the high point and the weeks immediately following the show the low point. However successful or unsuccessful an exhibition is, when the parties, reviews and sales cease and work starts on the next show, depression sets in. That is until the next opportunity to exhibit arises. Within this pattern of exhibiting, most successful artists will show in every gallery they have a relationship with every two years or so (two years being what received opinion considers a suitable recuperation period for everyone concerned – artist, gallery owner, buyer and critic). The artist's commercial and emotional life intermeshes with this pattern as a series of peaks and troughs that punctuate the two-year cycle. From the buyers' or viewers' perspective this situation is equally disconcerting. What they are left with is the postcard as a quick reminder of what is available. In fact, they spend time looking for the right one to get hold of rather than looking at the surface of the real thing.

Regrettably, in the art world there is still no equivalent of the book or record shop. Imagine an art gallery on a high street anywhere in the world where it was clear from the moment you walked in that everything was for sale; a retail outlet that didn't pretend to be a museum or an auditorium but offered a range of goods for sale. It would be like a Virgin record store. To the right of the entrance would be the current top twenty – Damien Hirst, Tracey Emin, Chris Offili, Sam Taylor-Wood, Steven Pippin. There would be small affordable works or gigantic blockbusters represented by photographic or video images. Deeper into the store would be more works available by the same artists dating back to their student days. At the back, on the ground floor, there would be a number of sections – Foreign Artists, Female Solo, Double Acts and North American Classics. Upstairs

there would be a room containing minimalist works and another modern masters; these would be quiet areas with comfortable seats, added security and slightly older sales assistants dressed not in black Lycra but Prada and Armani, communicating like vergers in a whisper.

For the new art there would be booths where videos and sound pieces could be viewed and experienced – even a section for old rockers and another for young unknowns. By the upstairs sales desk there would be an area for T-shirts, merchandise and low-price multiples: objects or images produced in limited numbers but sold cheaper than limited editions of prints or sculpture (recently Sainsbury's Homebase stores collaborated with the Tate Gallery to produce artists' versions of such products as garden tools and nails; they were a complete sell-out). Here fans could also purchase magazines and books on art for themselves or for friends at Christmas. In fact, modern art is gearing itself to this change. New artists, no doubt in response to the inadequacy of the current distribution channels, are producing work that can be viewed directly on a TV or computer-screen, ready to be downloaded as an integral work of art from the Internet.

Whether you find such a scenario acceptable or not depends on whether you feel that art should be more accessible (certainly the direction our culture seems to be moving in), or whether you feel it should demand more of its audience.

Museums

When Bryan Robertson was director of the State University of New York Museum he arranged for these words of Bernard Shaw to be inscribed at its entrance: 'All I want to say is that the only possible teacher except torture is fine art'. When Robertson reminds us of Shaw's words he also, reminds us of the shortcomings in our own education. If looking at art is important, and not only takes time but also requires a specific set of study skills, it is surprising that more is not made of the subject in our schools. Just as most schools don't encourage their students to spend time studying works of art, museums have followed art galleries' lead and tend not to encourage their audiences to spend time in front of exhibits (when was an artist last

in charge of a museum?). If literature were handled in the same way the whole of Shakespeare would be dispatched in one lesson by a potted summary of all of his plays.

In theory it is good for artists to sell a painting to a major public collection, but as most visitors thus spend only seconds with an object that is intended to be looked at length, it seems doubtful that museums are still the right place to find a public. Today, they are art routes that take you from foyer to bookshop or restaurant with a selection of chosen views (the pictures) on the way, herding you from one retail opportunity to the next. With a keen eye on turnover, they have introduced pay-for stereo sets that prod the visitor to spend the length of an explanation in front of a work and then keep moving on. Seats are to be found en route, but they are intended as points of recuperation for the elderly and bored, not places for study or reflection. Having perfected the art of postcard selling, museums fill their retail space with rows and rows of cards that are a miniature, bite-size and watered-down version of the collection.

Museums take this elevation of the unimportant one step further by presenting art as part of an educational package. One telling example is an exhibition called Modern Starts held at the Museum of Modern Art in New York. The catalogue told us that it was an exhibition in three parts, People, Places and Things, exploring the beginnings of modernism during the period 1880 - 1920. *The Red Studio* by Matisse was one of the most important paintings on display. However, it was hung in a very small gallery in the company of some maps of the exhibition, a sculpture on a plinth by Brancusi, *Woman and Guitar* by Picasso, and some caption boards. This was the start of the show, which visitors more or less stumbled into once they had bought their ticket and passed through the turnstile. It is difficult to understand why such a beautiful and important painting, which takes time to be looked at properly, should be used by curators and pedagogues as nothing more than a mood-setter and random signage.

No one stayed in that gallery because it was crowded with people. They went in, saw that it was impossible to spend time with the painting, turned round and left. The exhibition as a whole worked as a large-scale history lesson that shoehorned each work into an intellectual position chosen for it by the curator. Hung like a stamp in a

collection, each work was crammed against the next, offering no space for the audience to enjoy the constituent parts. It was an exhibition that placed the curator at the forefront of art history and reduced the roles of the artists and their work to those of pieces in a jigsaw – important in creating the bigger picture, yes, but worth lingering over?

Modern Starts is far from unique in presenting art in this way. In an attempt to make art more accessible and attract larger audiences, galleries have become increasingly interested in interpreting their collections along thematic lines. As a way of framing the work, this kind of display turns each artwork into a clip from a film or a marginal illustration in a book. *The Red Studio* was painted to be visually self-sufficient and sufficiently robust that an audience could, if it wished, spend hours or even years looking at it. It was and remains a major achievement, as does *The Moroccan*, another Matisse displayed in the show. The guide informs us that the painting tells

A distinctive story about a Moroccan scene that is only put together by jumping visually from one part to the next. Instead of making a picture of a story then asking us to imagine it coming to life, Matisse asks us to participate in the creation of the story by making the story come to life in the time of our viewing.

How can an audience possibly collaborate with the maker and interact with this complex image if they are left standing in what is effectively a roadway through a gallery? The catalogue notes clearly state that the picture needs to be given both time and effort if the audience is to plumb its depths, but it is displayed as if all that is expected of the viewer is a fleeting glance as they pass on to the next piece. In short the design of the exhibition treats this and many other pictures in the show as fast food, when what the curators had in their hands was the makings of a sumptuous feast. What results from the mismatch that so often exists between what is written about art and what we actually experience before the object is a detached or mystified audience, exactly the opposite of what was intended.

4. The Exhibition

The Frame

Most artists pretend to have little interest in frames. But if it is a question of an expensive frame they usually enjoy the ennoblement it offers. Other than that it doesn't really concern them when creating a work of art. Dealers and collectors, on the other hand, like frames, and can spend hours in the art world's gift-wrapping department. Frames traditionally provided a neat border to what might otherwise have been an object or idea fresh from the studio with rough edges. The shorter twentieth-century history of frames is that they started as heavily moulded and gilded gesso-and-wood objects and ended up as functional strips of plain wood or metal, or on occasions ceased to exist altogether.

We now think of a frame as more than just a rectangle of metallic or wooden moulding. A frame is both a physical and a conceptual container. So an architectural space, a gallery, even the owner of an artist's work, can be understood as part of the framing of a work. Madonna owns this painting by Frida Kahlo, Baron Rothschild that painting by Lucian Freud, Peggy Guggenheim owned the other by Ernst. Throughout the history of modern art the dynamic relationship between the art object and its owners has had an effect on the perceived value of work. It has remained the case that the wider the influence of the owner in the art world, the better the conceptual frame. So the frame may have moved back from being a decorative to a functional protective edge, but it has remained part of the drama.

Max Ernst's *The Elephant Celebes* has acquired an interesting social frame. Owned originally by artist Roland Penrose, who purchased it from Ernst at a time when no one in Britain had any interest in the Surrealists, it was sold to raise cash to help the Institute of Contemporary Arts out of financial difficulties. The painting was purchased by the Tate and the surplus from the sale's proceeds put into a trust named after the painting. The Elephant Trust has, since 1975, assisted artists and galleries with projects that the trustees consider 'elephantine' – those that are offbeat, possibly surreal and which the trustees consider correspond with the interests of the founder. In short this Max Ernst painting has acquired an interesting history as a result of its move from private to public ownership and because of the philanthropy of its original owner.

81

One of the interesting preoccupations of the art world today is repackaging artists. Although all artists hope to be famous in their lifetime, most are not; most, if they are lucky, get just a taste of fame. Collectors and curators put considerable effort into unearthing work that in its day may well have been ignored and identifying appropriate pieces for repackaging and rehabilitation. A case in point is that of Stanley Spencer. During my youth his large painting of the churchyard at Cookham was hung on the staircase that led down to the basement of the Tate Gallery. One of the most noticeable actions of the current director was to rehang a number of the galleries. Spencer was one of the artists whose reputation and value at auction were enhanced by this – simply by taking the picture from the stairs and placing it centre-stage in one of the key galleries the artist's reputation was refreshed. Critics, of course, play a vital role in underscoring the activities of dealers and gallery directors, and a favourable review of a 'new hang' can be even more important than the public's response in terms of bench-marking the artist's market position.

In the case of living artists repackaging often involves bringing new evidence to bear on the understanding of an artist's work. Many female artists were repackaged during the last quarter of the twentieth century – the most important piece of evidence brought into play in many cases being their gender itself. Traditionally it was a disadvantage to be a female artist; now it is an advantage. Gwen John was Augustus John's sister – she is now considered by many to be the better artist; Sonia Delaunay was Robert's wife – once he died her reputation as an artist took off. In both cases it wasn't the work that changed, but the art world's perception of it.

The business of acquiring a work of art is rather like adopting a child; value judgements on both sides of the deal tend to focus on the individual's notion of what is a good home, and what is an appropriate price. For the artist, the money and a good home are of different degrees of importance. The home is most important, as it should ideally enhance the reputation of the artist and enable the significance of the adoption to percolate through to the greatest number of people of influence in the art world. What the artist hopes is that one sale will lead to the next, and that subsequent sales will continue through an unbroken chain of purchasers until his or her death. The cash reward is important, but not as important – all artists are used

to living hand to mouth, moving from bank to bank and relying on the support of partners. The price of a picture is often no more than the size of their overdraft. Only late in an artist's career, and only for the successful ones, does real money begin to kick in.

For big collectors, buyers and investors – those who may 'frame' the art in the right way – theirs is the art of balancing the pedigree of the artist against the price which is at the heart of investing. Buyers always know what they can afford, but most can never be certain of the long-term prospects of the artists or the work. (If there is a golden rule it is buy early and buy cheap – most artists become more expensive as they get older, but most don't get better.) Well-known collectors tend to play their cards fairly close to their chest when shopping for art. Like all gamblers they don't want to change the odds before the win is within easy grasp.

The exhibition Sensation is a model example of the collector's craft. It showcased some of the British collector Charles Saatchi's modern art, started life as a project that would help the Royal Academy in London out of a tight financial spot – a major collector lending the highlights of his collection to form the basis of a blockbuster high-profile show for a strapped-for-cash charitable institution. What also happened was that a lot of quite rough ideas by new-blood artists ended up with a quasi-royal seal of approval, acres of press coverage and a world tour. The RA did benefit, but at the same time exposure of the collection to a mass audience clearly added value very quickly to the works in the show.

Collectors realise that press stories about money are today's most valuable frames. It does not matter what story – it may be a record auction price or a history with many twists and turns, sex and blackmail, as long as it raises the issue of spectacular in-creases. In 1936 a painting, innocently hung in the collection of the Stadtische Museum, Frankfurt, is noticed by Hermann Goering, condemned as degenerate, then confiscated for what transpired to be home use. A year later, for reasons unknown, Goering sells the picture through a dealer to the Dutch banker Frank Koenig. Koenig, concerned for the picture's safety under the Nazi regime, then sends it with a friend, Siegfried Kramarsky, to America. In 1990, Kramarsky's widow sells the picture through a New York

auction house for £48.8 million to an unknown but presumably outrageously wealthy collector.

What interested the press about this story was not just that a simple oil painting can rise in value during the course of a hundred years from virtually nothing to £50 million, but ultimately that this piece of canvas as opposed to those innumerable others lingering in provincial museums was an unsuspected object of exceptional value. It can travel across the Atlantic having spent time in a museum, followed by a short spell in a fascist field marshal's bedroom, and finally become the centre of a legal battle concerning its ownership (the Koenig family are today reasserting their ownership of the picture, which is the peg on which the papers hung the story when it recently did the rounds).

The irony is that the painting in question is a portrait of a French doctor of no apparent distinction. In fact, history would almost certainly have passed over Dr Paul Gachet had Van Gogh not been assigned to him as a patient shortly before his suicide, and shortly after he had made the observation that 'this man is sicker than I am'. What this story highlights is the extraordinary ability of something as apparently pointless as a painting to assume a role comparable to that of gold and diamonds in the criminal, political and corporate investments arenas. At the heart of this is the magnetic pull exerted by the rare, and a desire for certain people in society (artists, and possibly some collectors) to acquire the kind of magical skills evident in the Midas story: once touched the gold remains gold.

In this race for gold the auction house has become the benchmark for the art world. Where Déjeuner sur l'herbe outraged Paris society because of suspect morals, the modern art world's ultimate weapon to shock is the skyhigh prices. Yes we believe that art is worth money, but that much, really? Conversely there is some satisfaction when works are sold off cheaply. As a consequence, auction houses are places most living artists like to stay well away from, and indeed I believe they are best left to the dead, the desperate and the exceptionally successful – the value of an artist's work is publicly tested at auction, with the result that, while collectors can pick up bargains, artists' reputations can be destroyed with a single stroke of the auctioneer's hammer.

One collector told me about a sound strategy he had developed

when buying art at auction. He completely ignored his personal tastes. His plan was to identify the artist with the greatest historical reputation but with the lowest recorded price gained at auction, and then concentrate on buying as much of their best-quality work as he could. This he successfully did during the 1980s by purchasing the unfashionable André Masson, Lucio Fontana, Tom Wesselman and Joseph Albers, among others. What was on his side in this operation was taste. He was working not with it, and not against it, but before it.

5

The Young
To Become an Artist

Young people go to art school to become artists, which they believe is an exciting and prestigious occupation. Most soon realise that the chances of them attracting any of the limelight are remote, and that what is even more remote is the possibility of earning even a modest living from the activities embraced by the fine artist. Those who carry on are usually either manic or reckless. Recently Susan Greenfield, director of the Royal Institution and Professor of Pharmacology at the University of Oxford, qualified this observation by suggesting that all artists are manic though not all manic people are artists. Nonetheless, I strongly feel I belong to the latter group, but then I am sure all artists would say that.

It is worth bearing Susan Greenfield's point in mind, especially when looking at the best art, and when trying to establish why it was made. The bad art, I believe, is easy to explain. While cannibalising their colleagues' art, artists do produce undigested work, sometimes a lot of it. But bad art is mostly made by people who want to be artists but who are effectively adapting and remaking objects and images that already exist without any mental acuity. In echoing the original, these objects are very useful as decor for the domestic and corporate markets, but they seldom show their head above the parapet in terms of art history and museums.

The exceptional works, however (of a quality that in science would win a Nobel Prize), I find difficult to pin down. The very best of the visual arts is, unlike the sciences, made independently of the university sector, research grants and team support. It is often financed speculatively and constructed in the equivalent of a shed at the end

of the garden – where there seems no doubt it would stay were there not a need for it. The price of art suggests that the need is big. As with gold and diamonds, prices fluctuate, but the key to the market seems to be scarcity value. So, like the blown dodo egg which today is clearly useless, art sits on the collector's shelf waiting to be admired while cunningly preserving within itself the owner's accumulating assets. It begs the question where does the good artist come from?

Going to Art School

While museums may be places where artists have their mid-life crisis, art schools are the places where the reputation of their art begins and ends. The young would-be artist goes to art school to learn both what art is and how it is made. For some this works, and they go on to be artists; of the rest, some discover how to make art but have no interest in going on to make it, while others discover what art is but never really come to grips with making it. This results in there being at the end of each decade just a few emerging from art schools who the profession feels confident in naming as artists; the rest are either struggling or declare themselves non-starters.

Art schools use as the focus of their curriculum examples of historical excellence, the assumption being that the creative, gifted and talented – call them what you like – go to art school in order to understand, and make work that is informed by, examples considered excellent by their chosen institution. Art dies in art schools when students and teachers cease to feed from it. Sir William Russell Flint, for example, was thought by some to be a first-rate artist, but on the evidence of his reputation's trajectory during the past forty years I feel confident in saying that he will never in the future have any substantial effect on shaping the work of emergent artists. His work, as far as art schools are concerned, is therefore dead. By way of contrast, it now seems unlikely that Picasso, for the foreseeable future at least, will cease to provide a model for would-be artists, while Jackson Pollock and perhaps even Andy Warhol may in the face of modern technology be slightly less secure.

At the heart of the art schools' approach is the teaching and practice of a set of craft skills based on each school's preferred models. Traditionally, the most important of these skills was one that in most

teachers' minds went well beyond being simply a craft; one in fact that many saw as the very grammar of art: drawing. At the periphery were the crafts that probably attracted students into studying fine art in the first place: painting and sculpture. It was unusual for a student to practise both, as almost everyone felt that the world was divided between these two disciplines. There were those who could translate their experience into two dimensions, and then a small, dedicated, mostly male group who carved out a position for themselves in the art world by realising their work three-dimensionally. By the end of the twentieth century this divide had more or less totally disappeared, but it was an established part of art educationalists' sense of order until relatively recent times. Certainly this was more or less the way I found things when I first went to art school in London just before the start of the last quarter of the century.

By the time I set out to become an artist, and arrived on the Charing Cross Road at the St Martin's School of Art, there had been a little tinkering with the curriculum and its presentation. The importance in some of the teaching staff's minds of drawing had diminished, and print-making and photography had been introduced to the range of crafts taught. Everyone studied art history and a subject called complementary studies. In short there had been a modest move towards the broadening and modernisation of the crafts taught, and a drive towards intellectualising the study of fine art through historical and other studies. The latter required art students to engage in both reading and writing. This didn't go down too well with some art students in the 1970s, as most imagined they had escaped further engagement with each of the three Rs by opting for an art education.

The most radical aspects of the curriculum were for me to be found in the complementary studies course, and from time to time in the one-to-one tutorials on our work that took place with successful artists in the studio. No one ever explained why we needed to take a subject called complementary studies, but with hindsight I now realise it was simply to wise us up. My teacher was a Dr Stephen Black – a hypnotist, as I remember, although he was probably far more than that. He talked to us about creativity, will, freedom of choice and so on, and at one point brought in one of his patients, whom he seemed able to take under his influence with amazing ease.

In some respects we treated his class as a laugh, but in other ways I suspect we valued working with this clearly well-informed and wacky scientist. I remember that our end-of-course task was to write a systems analysis of a machine we were required to design. It had nothing to do with fine art, as far as I could see at the time, but it remains a memorable part of my experience as an undergraduate in a way that those life classes during my first year never will. I suppose what I learned was that hypnosis is a more challenging concept, more difficult to understand and possibly more relevant to a student of art, than both human anatomy and the unquenchable drive of the adolescent to view naked flesh in life class.

Today art students don't starve in garrets, nor are they very different from students in any other subject. There are plenty who are very bright and a few who could be described as average, but I don't know of any whom you could describe as dull. They are in general a lot of fun, hard-working, thoughtful people who tend either to be recluses or have an unhealthy interest in their self-image. They are not the transparent types who silently do good work in libraries. They are usually full of ideas that they need help to realise, one of the most important points I have tried to get over in this book. Artists are not gods. They are people who have chosen to follow a vocation, or else feel they cannot help but follow it. They are not a special type of person. If they are good, it is simply because they are creative and energetic.

Art schools these days are totally different places from those I knew as a student and when I first started teaching. For the first time since the Renaissance, artists are now using cutting-edge technology, the same technology that science and the commercial world use in their work. This has resulted in the curriculum no longer being adequately described by the craft-oriented labels we have become accustomed to as a shorthand for deciding what type of artist someone is. Painter, print-maker, sculptor – even photographer – now seem archaic and artisanal ways of describing an artist's identity.

Increasingly we think of what is taught in art schools as being either two- or three-dimensional, static or moving image or object, digital or analogue, and of being mechanically or manually rendered. The reason is that although some students and artists still choose to paint on canvas or carve stone, the majority are working with cam-

eras and computers or assembling the found, machine-made or even their own bodies into works that are variously described as performative, installations, interventions or projections. The excitement that artists currently display towards deploying new technology is, of course, not new. Vermeer, along with many other painters, used drawing machines to pursue and capture reality. Ruskin and Degas were both excited by and deployed photography for similar reasons, while Marcel Duchamp gave just about every possible image- and object-making process a whirl once he had done with painting.

What has returned to art at the turn of the century is the willingness of both the makers and their audience to accept new technology as not just a component of high art (its contribution may or may not be revealed) but a celebration of it. Because of this substantial engagement with new technology during the last decade, art has changed, and so have art schools.

This re-engagement with the notion of progress and with it a belief in the worth of new technology suggests that post-modernism has run its course. What we find ourselves with through instantaneous communication across the globe is new modernism. What attracted the artist to the post-modern was the lack of content they needed to establish and the freedom and fun of mixing anything with anything. Just as the Baroque followed the Renaissance, so post-modernism followed the purism of modernism. It was as though on each occasion artist rewarded themselves for years of refinement and serious devotion by declaring a play time. But play time lasts only so long. After having run wild artists want to push content back into their work. The excited engagement with new image technology has fuelled again a belief in progress, a belief that art is moving in a certain direction rather than spinning wheels through various media.

Young artists now want to learn new skills that will enable them to work with video editing and electronic image-handling, and out of this inevitably comes a need to work with light and sound. If you ask anyone involved in curriculum design they will, I believe rightly, tell you that, because the week cannot get any longer, for every subject you add to the curriculum something has to go. So what has gone? This will, of course, vary from country to country and from institution to institution.

The common denominator, however, seems to be the time avail-

able to art students for play and experiment. They are without doubt better informed, better theorised, more able to write critically, and physically and conceptually in closer contact with new technology than their predecessors, but they seem to me less able to sit in a studio and freely manipulate their chosen medium. Most artists of today's middle generation were encouraged during the course of their education to see ideas as coming out of practice, so most find it odd to see how young artists import ideas into the art school then simply seek out the technical support they need to realise them. Like visualisers in the advertising world and impresarios in the film world, art students and the new generation of artists have become ideas people. They have more or less detached themselves from crafts and getting their hands dirty and have placed themselves in an executive, white-collar class.

Change

Art schools must respond to this to change. They can no longer be all things to all people and hope to give their young artists the depth of engagement they need. The change that faces art schools today, is more fundamental than ever before and more than adapting to the change in the range of the tools of the trade of the artist. Art, as always, has to straddle the past and the future by working in the present. But it has become physically impossible to encompass all new developments in one curriculum. One school cannot hope to offer both a thorough grounding in the art and methods produced by artists in the past and hope to cover cutting edge technological instruction – which may have to dig deep into the hardware of the technology.

Some art schools would thrive as nurturing environments for the creative imagination of young artists through the acquisition of craft skills, play and focus on the production of hand built objects and images. Such a studio course would continue what is taught in most art schools today. Other art schools would thrive as advanced schools of art. Young artists would focus in these schools on a study of a visual culture that is truly international and cross-disciplinary. They will need the access to the most modern tools available, and get access to the latest in engineering, electronics and web communica-

tion and imaging. Of greater importance than the history of art will be the history of ideas through science, mathematics and behavioural psychology. Instead of exams, they will work to make creative use of the ideas and possibilities they are handling. Most importantly, leading artists – who seem to give art schools and the next generation of artists a wide berth once they are famous – should be attracted to give students contact with the most prestigious members of the art world.

Conclusion

Here I would like to revisit my phantom symbol for art from the beginning of the book – the image of the farmer looking back across the stook-filled cornfield, having stopped on his way to the barn because of the sound of a gunshot. We know that this was the moment when Van Gogh took his own life, and we suspect that the farmer would probably recognise the gunshot only as a typical sound of the countryside, and not, as I suggested, as a significant moment in the story of art.

What I believe this image symbolises is the moment when artists began to understand that to work alone and to be genuinely inventive and extraordinarily creative was beyond most of them – they simply didn't have the emotional and physical resources to sustain this approach. So instead they started slowly to return to the Renaissance model of the artist as the leader of a workshop or a project manager; they stopped staring at the bare canvas and searching their souls and turned instead to problem-solving, time-limited projects and working to commission.

Van Gogh went down a similar road to Pollock, one that turned out to be a cul-de-sac; both were test-piloting a high-risk approach to the practice of a craft based on a dream of creativity. At the end of the twentieth century few artists think the dream is worth the risk, and quite clearly the audience and collectors no longer require them to take it. Where once they had expected evidence in an artist's work of a deep emotional engagement, now a lighter engagement, as well as lighter content and physical touch, have become the order of the day.

The twenty-first century will inevitably produce risk-takers, as well as artists who become so frustrated by their inability to find new

ground that they give up on life. The majority will, however, work in the world of mass communications, producing creative video, film and interactive websites for large audiences. A smaller number will continue to nourish museums, collectors' homes, galleries, corporate interiors and the imaginations of a fairly small audience with images and objects that aim simply to externalise the maker's view of the world, made for roughly the same reason that you might write a letter to a friend or a newspaper editor. The audience will engage with these objects, which will probably still be called art, because they will find the way the maker uses a visual language attractive or inventive, and because they find the subject matter and content of the image or object both interesting and challenging. And artists will continue to fight to be noticed – which is, after all, what they do well.

6

The Abstract
Words about Art

Balzac's novel *Le chef-d'oeuvre inconnu* describes the ultimate paint-ing, the painting of all paintings. Frenhoffer, a highly respected artist, is known to be working on a depiction of the human figure that his students and admirers believe will be the most real image of a human being ever painted. The work is being carried out behind closed doors; no one is allowed to see it before completion. When finally it is unveiled there is hardly anything on the canvas other than the trace of a foot emerging from a primordial soup.

In reality the painting could never have been made by Frenhoffer at the time the book was written (interestingly Picasso missed this point when he illustrated the story in 1931 for the publisher Am-broise Vollard). At the beginning of the nineteenth century art had not yet reached a point, either conceptually or intellectually, where the dissolving of detail could be viewed as heightened realism. Through literature, Balzac foresaw the direction of art in the future. In fact it took about 130 years before an image that approximated to Balzac's idea emerged as part of the natural progression of painting, in De Kooning's oeuvre.

Drawings and sketches are less concrete than painting and sculp-ture. They are the architect's initial plans, while paintings and sculpture are the completed structures – drawings with clothes on. They also have the capacity to be ahead of their time. Three hundred years had to pass for the thinking behind Leonardo da Vinci's deluge drawings to be turned into paint. Leonardo simply did not have a way of doing it; in paint he could cope with the *Mona Lisa* or the *Madonna of the Rocks* but nothing more complex. It was Turner who found a

way to do it, Turner who managed to find a credible way of painting nature that roped the viewer in.

At first sight abstract art may appear highly sophisticated and 'difficult'. In fact it is none of this. All art is people's art, because it is nothing more than pure line, form and colour, and as with a good tune or, perhaps, at the other end of the scale, a major overture, we should be able to lie back and 'just enjoy it'. No complex iconography, no theory, is necessary to its understanding – it is simply the product of one person celebrating their physical and emotional relationship with a set of materials, with line, form and colour, and, in some instances, with time and space as well.

If you don't understand a particular work or artist, if you feel up against some kind of opaque middle-class sign language, it is best if you immediately write such art off as furnishing and decor, as there is no other way in than through your heart – that is unless you want to view art as an historian. But with no art history, no artist's biography, no research, you can train yourself to look at and understand a painting or sculpture made to be lived with and absorbed slowly. This is an exercise that cannot be carried out using mechanical reproductions or in a social context; it takes between forty-five minutes and an hour and requires the viewer to write whilst in front of the picture.

Appreciating Art from Scratch

For most of us, the point of visiting art galleries and looking at art is to discover things we like and then draw pleasure from them. It is not to establish what we don't like – this happens by default. The reason one likes a painting and has no interest in or positively dislikes another need not have anything to do with taste. It can be because somebody has influenced us with a sound argument or a skilful use of language.

In order to explore a work's qualities I believe it is important to have a set of criteria with which you judge. Clearly, for some, visiting an art gallery is like going to a party in search of a potential lover – they swiftly move through the field looking at what's on offer, then once they have got the feel of the range of options they strike and out of the mass select their preferred target. Their satisfaction comes

from exercising their choice. For others, visiting a gallery is more like social work, or perhaps even doing a jigsaw – place a problem before them and they will wrestle with it until they believe they have made sense of it. The satisfaction lies in solving the puzzle which the artist faced.

What any sensible viewer should be doing is applying a fitness-for-purpose test: try to establish what the image or object is attempting to achieve, then whether it has succeeded in its goal. The point of the exercise is to find out what, say, a painting is about by looking at the evidence of the surface of the picture. There are two basic viewpoints, one about two metres from the picture (for works up to two metres square), or farther back for bigger pictures; the second a close-up from about thirty centimetres away. The viewer needs to be fairly comfortable, so start with a painting you like which has a seat in front of it. In effect, there are three questions one asks:

1 How is the work of art made?
2 What describes best: – Its surface;
 – Its colour;
 – Its tone;
 – Its shapes;
 – Its space;
 – Its allusions;
3 Finally, what you think it's all about

What follows are a number of examples of the application of this working method. Each took about one hour to write and was composed in front of the painting or sculpture referred to.

Vincent Van Gogh, Sunflowers, 1888, National Gallery, London. 13.4.96

Quite carefully painted with thickish creamy oil paint on canvas which is totally obscured with rendered wet-onto-wet paint put on with a decorative touch. Built up slowly in a way that suggests that the placing of a background against some flowers was the priority in its making. It is as though the adjustment of colour and the building up of the intensity of that colour have caused the painting to be as it

is. Not a need to paint flowers. There is no trace of the problems of drawing and picturing the flowers in their vase. These seem to have been dealt with effortlessly while concentrating on other things.

From a distance you are only really aware of an intensity of colour, carefully constructed colour, but possibly of equal importance and less obvious is how the texture of this paint is both a part of the colour and the making of the picture. Each object is painted up to its edge and the background is painted up to the edge of each object like a detailed yet slightly rough manicure. The background is built from little steps of paint interlocking like parquet flooring, made with incremental brush strokes three-quarters of an inch wide with a flat hog's-hair brush. By way of contrast, a smaller round bristle brush like a pencil without a point has put blue lines into the vase and cut the table top from the wall. A picture that's not so much painted as carved into wet paint with a brush. Covered in brush strokes and globules of paint, the flowers are iced on while the background is chipped out into a rough flatness.

There is no part of the painting where the surface is at rest, only the bottom half of the vase beneath the artist's signature sits with a slightly less worried surface. The lower flowers hang in profile close to the vase, more decorative and in greater relief than the upper flowers, which appear full face and less gratuitously in impasto. As though cast in polished and patinated bronze, their texture contributes to their colour, there is very little illusion, they appear as concrete and actual things. Close up, texture prevails. When the picture first catches the eye it is that the background is so intense that the subject, the sunflowers, look dull, not golden, brown. The surprise is green paint added in the right place as stalks and leaves and as centres to the flowers, blue paint which is even more sparingly used is restricted in its use to describing the synthetic. A line on the vase, a line running next to the edge of the table and a signature. The picture appears to be painted in local colour, the colour that we know things are, but the background yellow marks itself out as too powerful to be real, so must be an invention.

Mid-toned flowers on a light background fixed to their vase and in turn a table-top by the continuation of that tone. Chinks of light show through between the petals and stalks of the flowers. There are no painted lights in the central image excepting a patch of white on the

shoulder of the vase which seems to mark where a handle may have broken off, a rather prosaic detail in such an unworldly painting. Bringing just a little light into the lower third of the painting, the texture of the paint on the flowers produces lots of actual highlights on its peaks, lighting up the central sombre image of flowers, preventing them reading as dull voids which tricks the camera and eye into believing that they are painted.

There is a horizontal division in the picture about a sixth from the bottom which is a table-top. Coming from this darker bottom are a series of circular blobs rising. First the vase, then the flowers connected on occasions by green tubes, their stalks. A simple structure like a portrait, a central lump with the edges left around it, loss of substance and not much space. Everything is here and now and either on the picture plane or trying to push its way in front of it. Even the blue line and signature that drag their way around the vase do little to suggest anything more than a shallow relief. There is no real space to place volume into, there is only substance.

The yellows of the flowers are made to look dull by the freezing intensity of the yellow background colour. With no effort put into establishing a realism, they owe their drawing to a decorative rather than a horticultural order. Made by a person who enjoys painting, they celebrate the activity such that we get to know more about colour and paint than flowers. The painting lifts the importance of the background and diminishes the importance of the subject matter. What is supposed to bring colour into an interior, cut flowers, is washed away on arrival. A word and a colour turn a picture of flowers into an essay on painting or authorship, where the power of colour and the name of an artist become its new subject and the content. The flowers are nothing more than a starting point and a popular way in for the audience, who will also be comforted by the word Vincent handwritten on the vase in blue.

Henry Moore, Recumbent Figure, 1938, Tate Gallery, London. 22.7.99

It has been carved from what appears to be two blocks of stone, cut clearly at the same time and from the same place in the quarry, then joined into one block. With the joint emerging as a fine but important

detail and as the only straight line running like a flaw in the weft of a fabric, horizontally through and around the image. The stones sit together like matching veneer, the top echoing the bottom.

The whole surface is matt and has been carved to look as though the sea made it, with not a trace of a chisel or rasp mark. Although clearly shaped by a chisel there is one trace of an addition – the filler in the hairline joint, which navigates the whole.

Only when you move in close and take a walk around does it become clear that a third block has been added – this is a one-foot cube of precisely the same stone, which sits on the top.

The tone of the stone is pretty much 'mid' and the same all over, but made darker and lighter across the surface by incidental light and shadows falling on its relief. Its darkest tone is at its foot in a deep undercut, its lightest frame the sculpture and are the white wall of the gallery around and its plinth. One bright white drives through the middle of the sculpture, again it is the gallery wall beyond, but this time made visible by a massive letterbox-shaped hole which penetrates the centre of the block. Because a roof light lights it, its top surfaces are lightest.

The colour is embedded naturally into the stone. In spite of the horizontal wavy stratifications there is a blurring of horizons so that there is no sharp divide between the ochre centre and the warm grey edges top and bottom. Apparently superimposed but in the end clearly embedded in the rock are some darker contours as if from a map or a fingerprint, located in the sandier areas. In a couple of places the dark rust calligraphic marks are complemented by some silver grey surface irritations caused by the natural occurrence of fossils.

The space taken up by the sculpture appears to be the same as an adult human would take if they were to sit on the floor, lean back on one elbow then raise their knees and pull their heels back to their buttocks. But in fact it's bigger and probably twice life size. The object reclines on a plinth like a small-scale seaside rockscape and in doing so delivers a compact version of the epic.

The shape is reminiscent of a mathematical knot that has been abraded by gravel then washed by the sea for quite a few years. This has resulted in the head being more or less featureless and a hollow developing in the lap that the head would neatly fit into. Topped off

by two unmistakably maternal but nippleless breasts, and supported by what are clearly arms and legs, the whole thing hits a mid-point between a lyrical landscape and an anatomy lesson.

The illusion the artist has pretended to build into this object is one of nature, not artist as maker. What are presented are two massive stones and one small block joined beautifully and cut carefully to look like a female nude developed or eroded by the sea. What is it about? It looks as though the artist wanted to exercise the lightest possible Midas Touch on some already beautiful fragments of rock and by doing so connect them to modern art. The artist also wanted us to be aware that he was considering archaeology, anthropology and geology while trying not to handle the female form too heavily and through the well-worn aesthetic of the worn. Giving the appearance of being unearthed from antiquity, this is exoticism without a trace of eroticism. A nude to be hugged and stroked but not penetrated.

Jason Martin, Confession, 1999, John Moores Exhibition, Walker Gallery, Liverpool. 23.9.99

This painting was probably made in one sitting by slowly dragging without visible restart or correction a custom-made metal comb across a surface of thick wet paint, then leaving it where it was made on the floor for some considerable time. The spillage and swarf thrown off during the act of combing are left to dry and retained as an important part of the painting. The comb appears to have been the total width of the picture, which is about two and a half metres square. The support that the combed paint is spread across must be ridged and not canvas, which would sag under the substantial weight of this thickness of paint.

The uniformity and control of the drag which took the comb across the surface and through the wet paint suggests it was supported by or run on rails. The surface is one of slightly tatty perfection and identical to what I imagine the greatly magnified surface of one of those old 78 gramophone records would look like after a particularly new and sharp needle had cut its way through the track had it been made in white chocolate.

What produces the music on a record and this painting are the irregularities in the groove. A track of horizontal, parallel and

straight lines about half a centimetre apart cut their way across the entire picture surface with two intended kinks. The edges where the combing begins and ends are to the left and right edges of the painting, each edge carefully retains the traces of the start and finish of the drag. The top and bottom of the picture retain a different kind of beginning and end to motion, these edges are where the next ridge would have been, just traces are left, most of the paint having fallen off the edge.

Given that it is made of white paint, which reflects light, and grooves have been cut into it, which are in shadow, and that fifty per cent of the surface is in shadow, it is surprising how white it looks from a distance. Close up it is generated not by lightening and darkening the colour, by mixing light with dark paint, but by the topography of the painting's surface. At points in the picture the ridges between the grooves have risen so high that they have collapsed in and covered the groove and taken out the shadow. Along these lines the tone lightens, producing bands of light paint running sporadically across the top two-thirds of the painting. The bottom third is free of this feature and as a result more even-toned.

The lumps of paint or swarf, as I referred to them earlier, which fell from the comb as its teeth filled during the drag, sit like rocks on the moon casting mid-toned shadows across the ridges and furrows.

It is made from all one colour of paint on its surface whilst its edges, which are only visible from the side, are grey aluminium.

Slightly creamy in colour and consistency, the flaky white surface is decorated with soft grey, pinstripe shadows. The whiteness of the surface is prone to reflect the colour of things near it – a red jumper.

The dominant shape is the square of the whole then those droplets of paint occasionally thrown off to dry like rocks in a ploughed field. As a painting that can be described quite adequately in terms of the mechanical processes that made it, it is remarkable to see how much illusion plays a part in the end product.

The vertical shift of a horizontal course that twice lifts, carries on for a little then drops back to its original track creates the perfect illusion of two buttresses running top to bottom through the painting. One about four inches from the left and four inches wide, the other a foot wide and a foot from the left. These corruptions of the track give the impression that the straight line as we want to keep thinking of it has not so much got a kink in it as been straight over a solid which

now forces us to view a straight line as distorted. The length and shape of the combed deviations from the base line determine the shape and thickness of the illusory object the line crosses. Beyond this there is no illusion. The painting is what it appears to be.

This painting is a virtuoso piece rather like the work of a pizza chef who thins his dough by spinning it like a Frisbee in the air – the artist amazes us with his ability to freeze a ridged and clearly wanted structure into gooey white paint. What results is a short journey into the spectacular sublime and a demonstration that there need be no substantial difference between painting and drawing.[1]

Brian Catling and Tony Grisoni, *Vanished* a Video Seance, South London Art Gallery. 31.10.99

Although it is constructed predominantly from light and sound, *Vanished* has a number of surfaces, the image on the screen is slightly frosted and the seats you sit on get harder as time goes on. The heads of the audience that partially block your view of the screen are voids that have no surface at all. The room is dark but not so dark that the mushy detail of the audience doesn't become visible if you look away from the screen and let your eyes adjust to the new light. Before and after *Vanished* the gallery where it is housed is lit, and all of its surfaces are visible, layer after layer of white emulsion paint moulds the detail of an oldish building into a slightly smoother set of surfaces than when it was built.

The artwork *Vanished* has an overall texture that is predominantly grainy with sharp points sticking out. The sharps come in the soundtrack of the human voice and from little spots of light catching a tooth or reflecting a retina among the images of the film.

Whilst experiencing *Vanished* you are in the proverbial white cube with its yellowish stripped pine floor, that is until the lights go off. At the beginning and end of *Vanished* the audience provide a mish-mash of colour, but once it starts, apart from the red pinpoints of light that sit above both doors and within the fire precaution system, the only visible colour is on the screen. Because most of what is offered visually comes in the form of talking heads, the centre of the screen is usually occupied by flesh tints interrupted by the animated darks and lights of the mouth and eyes. The costume and background that

usually fill the rest of the screen are puritan drab. The sound, which is tied in time and mood quite precisely to the colours on the screen, underscores the on-screen image and at no point modifies the coloured images in our minds.

Very light at the beginning and end, but during *Vanished* it is dark with a focal point of light which is the rectangular screen hanging in mid-space partially blocked in its lower third by the heads of the audience, which vary in form and size depending upon where you sit in the makeshift auditorium. The image on the screen provides a full range of tone close-ups of the actors' heads, providing everything from jet black in the retina to bright light from the sparkle of a wet tooth.

The male actor is always sidelit and from slightly behind, so his face tends to have softer tones and appears around the eyes and mouth slightly out of focus. His hair is thrown into dark, sharp contrast on the side he is lit.

The women are lit face-on so that the specular highlights in their eyes burn as sharp whites. In the faces the tonal contrast across flesh is sharp; lights are separated from greys from darks.

The audience sits in darkness in a box, in rows, side by side while the image on a flat screen is brought in as light. The audience sit in as static a state as they can, the images on-screen are studied and static. The head and shoulders govern the whole form of the event both on- and off-screen, anything lower down is ignored or forgotten. There is a beginning, middle and an end to both the image and event. It is light when it starts and ends whilst on-screen images more or less fill the darkness of the middle. The projected image starts with a house on the side of a hill then focuses on the emotional trauma of its occupants then lingers on their age and indulgent memories. There is remarkably little illusion, we know that projectors project and that actors act and that art galleries are artful. I am confident however that what we experience does contain considerable illusion, *Vanished* is full of the artificial but there are no tricks beyond what we see. Posed as an interrogation, it comes over as a confessional drama. It is not pretending to be real like theatre but acknowledges the audience's need to suspend their disbelief.

By presenting *Vanished* in an art gallery and not in a cinema or on television the audience is filtered along with its reception and possibly also its meaning. As a period play it takes you back in time

to wrestle with difficult relationships and emotions. An overwhelming feeling of guilt prevails over the whole event, not just in the minds of the subjects but I suspect the makers also. Like Victorian painting and sculpture it is high on drama, obsessively confessional and dramatically lit. Coming from a pulpit that expects its congregation to share in its guilt, it is an exercise in heightened realism which aims to jolt the innocence of the bystander. As an object devoid of any of the signs of its making, it sits as a beautifully crafted and well-argued essay on concealment.

Three Picassos

Once viewers have established an approach by which they can look at and explore the meaning of individual pieces of art, it seems to me logical that they will then want to go on to make cross-comparisons between the objects and images they have seen – seen not just during the course of one exhibition or day or holiday, but across anything from a year or two to a lifetime. To illustrate this I have used my framework to write about three very different paintings by the same artist: an angry history painting painted during his middle age, a portrait painted in the latter part of his life, and a radical figure composition painted in his early professional years. My reaction to each picture was certainly influenced by the viewing conditions and my comparison shaped by the time and space that exist between these pictures. But as this is the way we see and build our experience of art, the exercise to my mind remains worthwhile. For me the point of comparing these or any other pictures is to work out not which is the best but what the goals of each are, and then try to establish whether the artist attained them.

First I shall look at each picture as an individual work, then go on to compare them.

Guernica, 1937. Reina Sofia, Madrid

A large canvas intended to look like a wall, painted in fairly smooth oil with biggish decorators' brushes, except where it is linear and then a quarter-inch round hog's-hair brush seems to have been used. The paint looks more like the stuff used to paint walls than artists'

canvases, it is like a very rich and beautiful mural carried into the gallery.

Its surface is smooth with blotches of oil every now and again, which have no real reason for being there, other than because of the way the brush picked up extra oil from badly mixed paint or through poor priming which resulted in differences in absorption rate in parts of the painting's ground.

There is a full range of tones between black and white with transparent whites that let less mixed greys and near-blacks through. At first sight, all the lines are black and the same width. The picture appears to have been started with black lines on a white ground and then the greys, warm and cold, were drawn in. To the right of the centre of the picture there is a cluster of warm greys, the rest of the picture is composed with colder greys.

Painted entirely in mid-toned neutrals, black, transparent and now greying white, it looks not so much like a prototype as a panoramic monochrome movie screen. The line drawings in the picture vary from black to grey, there is nothing in the painting that by today's standards I could describe as white, as white as the walls of the Reina Sofia. The greys appear to be mixed from black, possibly two different blacks, one more brown than the other.

Structured around a triangle whose apex is the top centre of the picture, described on the right by the edge of the power of the light projecting from an eye and naked light bulb with a left side described by the perspectival edge of a table on which stands a chicken and whose vanishing point coincides with the light source. Two vertically rectangular rooms, like the wings of a stage, sit at the base of this triangle. One holds a screaming woman, the other a screaming man.

Centre-stage is a floodlit arena. To the left and right two interior spaces appear like shoebox theatres to the audience. Within the central arena a kind of Cubist hacking and dissection takes place. The dotted half-tone that some of it is described in reads like an image torn, cut and pasted from that day's newspaper. Although it is just about impossible to suspend one's knowledge of what one knows about this picture's history and intentions, it is quite clear that it is looking into issues of trauma and violence as they are experienced by people and animals who are not soldiers. The violence is clear-cut, like an explosion caught in the flash of its own light; everything is in

focus and in harsh light. There is no sentimentality, a soggy baby flops in its mother's arms. Within the narrative, only the bull's perfect testicles and the lamp carried by the hands of two spectators offer any hope for the future. Interestingly, the form of the picture suggests that time has been no real loss of order, or real destruction, just the shock and an unwanted interruption. In spite of the protagonists' screams and outstretched fingers, within this modernist language there is no breakdown of order.

The curtain pulled back frames centre-stage the innards of an explosion. A few small drips of paint give the impression of a hand working quite quickly but in a measured and careful way to produce a wide-screen centrefold image of violence.

The Sailor, 1938. National Gallery, London. Portrait of
a sailor on loan from the Bergruen Collection

Painted in thin oils onto fine white primed canvas that is visible at most points through the painter's paint, it is made using a basic language. That of drawing black contours then filling the white spaces left between with colour. The blacks are put on with a not continuous but seemingly endless quarter-inch-wide line made with a stiffish brush and not very thick paint. The line is sometimes grey when it has been drawn in later than the first blacks onto a not yet dry 'in-filling' colour that has a white in its mix, which greys the black. These greyish lines are usually not outlines but stripes on a vest or hat. The picture has two layers, the putting of wet black lines onto a dry white ground then the panelling in of colour and the lines that, wet into wet, go into that. There appear to be no corrections or changes of mind to speak of.

Painted in one sitting during probably a couple of hours either side of lunch, the surface is smooth, fast and fresh with very little sign of texture in the paint.

Around the eyes and mouth the paint is slightly thicker and wetter with more traces of the brush remaining. The paint is put on purposely thinly to give a look of freshness, virtuosity revealing how apparently easy it was to make. There are a lot of colours in the painting, blue, cobalt and chrome green which are the shadow of his hat, and viridian, pale sky blue, Naples yellow and pink, grey and

black and a reddish brown from which the pink is made. Which on his body is lighter than his face.

The Indian yellow around the eyes for a painting made almost entirely out of colour made opaque by the addition of white is odd. Straight from the tube, bile made traditionally from the urine of yaks fed on yams to make it even more golden. The colours intensify in the face and reach a peak on a red eyelid and a pair of metallic green lips chromatic in its top two-thirds, neutral and tonal in the rest. It's held together by a black scaffolding outline that treats generalities and detailed decorations and structure with equal force and importance.

The colour wriggles restlessly across the picture offering variations in tone and only rests in the powder blue of the sky, which is a lighter tone than the rest. Shapes are stressed to echo the brim of the hat, which flares like elephant's ears to echo the nostrils, which in turn ape the wet and bulbous lips. The strips in the hat flow in harmony and recognition of similar lines on his T-shirt. The eyes echo the nostrils and echo the ears, the hat and hand more generously re-enact what is going on in the head at chest level.

The picture is made up of a head and chest with hands that are not so much reduced to but explode with pattern.

Space and illusion? There's very little of it, it says I'm a painting made with paint, I'm flat. Around the hands there is more illusion of volume and interest, less use of colour; the painting becomes less tonal and casts illusion into the lighting. There is a strong sunlight burning down on his hat and shoulders while his face is cast into shadow by the burning straw brim. Giving the figure a space through light and temperature that close up it does not have. The play between the top and bottom of the painting is where the drama is. The face is so full of colour, the hands and chest dead tonal. The face is easily read and full of recognisable and nameable shapes. The hands, more complex and awkward, hold something I can neither properly see nor name. And within what is at first sight a simple and gay celebration of youth lurks a rather awkward puzzle or two.

The first is the lack of certainty over the lower part of the picture, not uncertainty on the maker's part but on ours. The second and the focus of the picture are those hoppers of transparent Indian yellow beneath the subject's eyes that are wetter and more transparent as paint than anything else in the frame, reading more adequately as

tears than flesh or light. A painting that from a distance smiles, giving off light and pleasure, but which cries on closer examination.

*Les Demoiselles d'Avignon, 1907. Museum of
Modern Art, New York*

It has the appearance of having been painted fairly rapidly using medium-sized brushes and fairly flat oil paint onto canvas. It looks as though towards the end of the making of the picture, once it was fairly mapped in, it was finished using thinner brushes loaded with either black, cobalt blue, white or brown lines, put on to detail the bigger lumps which make up the picture. Although the paint appears thin no raw canvas is visible and the tooth of the canvas is filled in by paint.

This appears fairly smooth from a distance but close up it is rough in parts. The parts that I suspect were harder to paint and certainly not resolved first time, so the painting reveals the struggle of its making through changes in texture and thickness across its surface. Notably it is a hand and a head on the farthest left figure, the fruit at the bottom and the two figures farthest to the left that have given the trouble.

The naked human figures which make up the bulk of the picture are in pinkish brown while the spaces between range from grey through to blue with the occasional area of brown. Outlines and detail are entered as brown, blue or white lines on top of the flesh tints. Green is the remarkable colour – cropping up just twice, it details the masklike face in the top right of the painting and provides the shadow beneath the backside of the seated figure on the bottom right. White cuts through much of the background colour as light. Mid-toned throughout, it tends to be lighter in the central background and darker at its edges. The mid tones are pierced in the top quarter of the canvas by the dark eyes of the sitter drawn in to stare back at the audience in black. Lots of loose triangles and kite shapes fit together as a rough repeated pattern within an arrangement that sits within the curtained-shaped edges of the proscenium arch. There is very little illusion in this painting. It is made to look like what it is, a painting. Only the eyes of the figures engage with you as illusion. The nakedness of the figures reveals little more than pink paint.

This painting clearly sets out to be understood as art, its subject matter carrying nothing more than a drive to blend native expression with the sophistication of the Academy. It is a painting of a group of naked females that is neither sensual nor erotic. For me it is impossible to pin down a reason for its being painted beyond a cold desire to make something avant-garde.

In order to make the comparison I want to look at why each picture was painted and then compare the success of each in attaining what appears to be its goal.

Guernica is an angry picture that sets out to cause a stir; it is big, it fills the field of vision with images of violence that are not everyday experiences but demand the audience's attention. It was made to stop the audience in its tracks and to be hung in a large public place.

The Sailor, by contrast, is a small, friendly picture that you could imagine in a domestic setting, if not your own home. It sets out to woo the audience, showing plenty of evidence of the artist's hand at work and giving an overall impression of well-being and intimacy, both with Picasso and the sitter.

Les Demoiselles d'Avignon is a large painting clearly designed for a public setting and not aimed at a general public. It uses its subject matter as a convenience and thereby separates itself from the intentions of the other two. It speaks to art history, to the language of painting and a professional audience in both the way it is designed and the way the paint is applied – to understand why it was made you need to understand the state of art at the time it was made. I would argue that this is not true of the other two paintings – they can be understood for what they appear to be: a portrait on the one hand and a violent drama on the other.

The Sailor speaks about the individual to the individual while *Guernica* speaks to a larger public about shared concerns. No one painting is, I believe, is better than the others. Each painting achieves its goal, each is a fine example of what the artist set out to do; it is up to us as the audience to prefer one to the others. What I hope to have demonstrated in this chapter is that, without falling back on the history of art, it is perfectly possible to engage in a critical monologue about individual works. Ultimately this monologue should turn into a conversation. The point of art is that it works its way into society and influences our thinking and society's sense of

order – what better way of achieving this than teaching society to look and simultaneously to talk about what it is looking at?

You will have noticed, I hope, that I never suggest that one work springs intellectually from another, never talk about movements, schools or -isms. I don't make an issue of when an object or image was made, or by whom it was made. Within the history of art these are vital details from which an understanding of the image or the object is constructed, but I would argue that it is all unnecessary baggage for someone embarking on a journey that hopefully has as its destination the capacity to enjoy contemporary art. For most, art history is best picked up gradually along the way, and not treated as the object of the journey or as a hurdle to be jumped before the journey can start. At the outset you simply need the time to look and some clues as to how to start looking.

Note

1. I met the artist as I left the gallery and asked him how he made the picture. He wasn't giving too much away, tending towards trying to pass the issue off with the Jackson Pollock 'I am nature' card, saying it was all in the translation of body movement into paint (so in fact like cutting a record of movement, not sound). He made it clear the work wasn't made on the floor but the wall, as it allowed him to move more freely, which I can believe, and that apparently the paint was stiff enough to be left to dry on the wall without sagging or dripping. He also told me another interesting detail, which is that he drags them over and over again until he gets a good one.

Appendix
Materials of Modern Art

As the twentieth century progressed, artists increasingly identified the potential in using art as the subject matter of art and art galleries as a stage on which they could not only exhibit but also perform. Exhibitions were no longer necessarily considered a way of showing the public what had been going on in the artist's studio, but were also regarded as an environment in which the artist entertained an audience. The distinction may at first sight seem a small one, but for artists the shift represented the difference between having to accumulate a body of work that might 'earn' them an exhibition and being given an opportunity, by virtue of their track record, to exhibit work as yet unmade. This empowerment changed the look of the art object and the role of the exhibition more than any other single factor. As explained in the book, the one guiding principle that has never changed, is that however new and shocking they may appear at first sight, all art objects will in the end relate to some extent to what has gone before. That is if you can be bothered to unearth the sources.

Today drawing lessons in art schools have about as much pulling power as a Latin revision class, but they used to be the backbone of art education. At the beginning of the nineteenth century drawing was firmly rooted in emulating the masters of the past. On the one hand were the disciples of Ingres, working on the edges of photography with mechanical aids such as the camera lucida, and on the other artists like Hokusai, trying to capture energy and gesture with a view to getting beyond appearance and into the spirit of themselves and their subject.

What these artists all had in common was a strong desire to learn

to draw like the high achievers of the past, and to evoke the look and feel of nature. By the beginning of the twentieth century this goal ceased to be a shared objective of leading painters. Picasso and Braque had begun to construct a wall between the nineteenth and twentieth centuries with what turned out to be one of the key constituents of modern and post-modern art.

Collage changed drawing for ever. This new way of image-building was based on the assemblage of the found, the torn and the cut. Pictorial space was folded and flattened, and images seemed to have more in common with the narrative space of Eastern art than with the Western intellectual tradition. Perspective more or less disappeared. To some it must have seemed that Picasso had lost his marbles. As an artist who could draw like an angel, why did he suddenly start rearranging the contents of his waste bin on a flat surface and ennoble them with a few lines and a signature?

Today very little old-style drawing goes on: pencil, charcoal and eraser are becoming increasingly rare objects in the studio and art schools, while cameras have proliferated. Every artist had a camera by 1980, and by 1990 many also had video cameras to harvest moving rather than still images. The point of drawing was to gather images in a form that allowed them to be easily taken back to the studio to be stored, to inform the making of a painting or sculpture. The camera all but replaced the sketchbook and pencil as the means of carrying out this task. With idiot-proof cameras, fast film, digitised tape and computers, artists could not only harvest their images accurately without years of training, but were also able to output the gathered information as a finished art object with minimal technical skill in their own studios. The camera was, in short, an amateur's charter.

As soon as Marcel Duchamp stumbled upon or hatched the plot for *Fountain*, 1917, he demonstrated that in the developed world drawing was no longer a necessary part of the preparation for making sculpture. Admittedly the design of his *objet trouvé*, a ceramic urinal, probably did start life on a drawing board, but not his drawing board, and certainly with no desire on the part of the designer to make art.

Painting

A brief history of painting in modern art starts in France at the beginning of the twentieth century with some groundbreaking work by the Cubists: Braque, Léger and Picasso. It then moves to the USA in the middle of the century, where abstract expressionism in the hands of Pollock, Rothko and Motherwell reorganised the activity into a rigorous and decorative formalism, before heading back to Europe for a look at post-modernism and the final years of the century with the work of Polke and Richter. Throughout the century warnings were issued to the effect that painting was in its death throes, but all the evidence suggests that it has managed to keep drawing breath. The divide between abstract and figurative painting has, to my mind, always been exaggerated, with arguments on the subject tending to be fuelled on both sides of the divide by reactionaries and low-achieving practitioners.

Only during the last fifteen years of the century was painting dislodged from its centre-stage position in the visual arts. Up until that point sculptors were the minority group, print-makers were the low achievers, and photographers and performance artists were struggling to be taken seriously. Throughout the whole history of modern art paintings have tended to be the main event.

Paintings became larger as the century progressed as walls, expectations, cheque books, studios and egos also grew. With this inflation the easel became more or less obsolete – it was simply too small for the job – so, by 1960, most paintings were created either on the wall or the floor. These new working positions produced new working methods, attitudes and materials as painting moved from the centre to the periphery of the art world.

Sculpture

Sculpture boasts a brilliant twentieth-century performance, distinguishing itself from other art forms in Europe by demonstrating considerable wit and vitality. Picasso started the ball rolling by simply walking away from the romantic realism of the nineteenth century and embracing the new and the experimental. In the middle of the century the big hitters were developing the discipline in the

USA, artists like David Smith through formalism and Donald Judd through minimalism, both using steel and industrial processes, both bringing a cool gravity to bear.

During the 1960s these developments were having some impact in Europe, and just about everyone but Henry Moore was taking stock of their position (Moore was quite happily profiting by following the tracks laid by Picasso). In the 1970s Britain rather surprisingly became a world leader, with artists such as Bill Woodrow, Alison Wilding, Anish Kapoor and Richard Deacon taking the scene by storm with their new and often witty Object Sculpture, which took the wind out of painting and replaced it on the international circuit as the acceptable and accessible face of the visual arts. The wit and fun of Picasso materialised as a mass activity in the hands of the younger generation who, unlike Henry Moore, had picked up on the joy rather than the pomp of Picasso.

Print-making

Print-making has been superseded by the World Wide Web and television, which affordably disseminate visual material to large audiences.

To the purist it is a craft that has its own aesthetic, capable of reaching sizable and non-élite audiences. It experienced brilliant eighteenth and nineteenth centuries in the hands of the satirists, and became financially serious and moody in the hands of the Victorians. Modern art can boast just two print-making peaks. One is reflected in the *Livre de peintre* of Picasso, Matisse, Léger, Joán Miró and Max Ernst, published by Teriade, Alecto and Maeght, among others, using large-format and unbound books printed lithographically on fine paper. These are best viewed by visiting the Herzog August Bibliothek in Wolfenbuttel, Germany, where a vast collection of these boxed prints can be seen and handled. The second peak was the print boom of the sixties that accompanied pop art, producing a wealth of popular images at affordable prices, often using the commercial process of silk screen printing. The rest of the time print-making has jogged along as a vehicle enabling dealers to reach the less-well-off collector and as a means of supplementing artists' incomes. This powerful commercial motivation for editioning prints breaks down,

however, when artists and dealers get greedy, to the point where a print costs as much as a painting or drawing.

Film and Video

As it became simpler and cheaper to use, and moved from being a professional tool to a domestic toy, so more and more artists understandably became interested in the informality video offered.

In galleries videos were played on televisions standing on plinths so as to look like sculpture, or hidden behind screens with holes cut in them so that they appeared to be paintings hung on a wall. Then batches of televisions were used stacked up on racks or pushed together as free-standing sculptures, with images divided across their screens. Then video projection was invented, and the image could be blown up to infinite size and projected directly onto a wall to fill whole galleries, or cover the sides of buildings. With these colourful moving images came other elements new to the art gallery – sound, darkness and, in many cases, no seating, with the result that the audience often didn't know what to do, or how long to stay.

All this will no doubt seem like a radical step away from the tradition of painting and sculpture, but it may be interesting to reflect at this point on something the modernist painter Fernand Léger wrote as long ago as 1933. 'I have dreamed of doing a film of "twenty four hours" of an ordinary couple in an ordinary trade, some mysterious apparatus makes it possible to film them without them knowing about it. They are subjected to an acute visual inquisition during those twenty four hours, with nothing escaping the camera; their work, their silence, their private life, their love life, with no editing.' This from a man who painted pictures with oil paint on canvas and who even today is regarded by some as nothing more than a formalist. In hindsight the project can easily be understood as the foundation of work yet to be undertaken by Warhol, Tracey Emin, Gillian Wearing and others too numerous to name.

Photography

Photography has, I believe, been the single most important technology to be deployed by artists in the research and production of their

art during the modern period. It started off small, and in black and white, and ended up big and in full colour. Originally it needed to be undertaken in studios and special darkened rooms with elaborate equipment and chemicals. Today anyone can make photographs of the highest quality, cameras are cheap, processing is fast. It is now the people's medium, and I'm not aware of any artist who doesn't use it.

Performance

If you are interested in theatre-in-the-round, being watched by strangers, pain, endurance, danger, body fluids and the gratuitous, there is considerable opportunity for self-fulfilment as a performance artist, but I should warn you that the financial rewards are negligible. If, on the other hand, like Peter Sellers in the film *Being There*, you simply enjoy watching, then being a member of the audience should suffice.

Performance and body art have a long history that goes back to pre-literate societies, rites of passage, tattooing and the circus, and in more recent times the showground and music hall. When asked why he didn't paint from nature, Jackson Pollock replied, 'I am nature.' So the scene was set for performance art.

Born in the Bronx ten years before Pollock died, Vito Acconci has spent the last thirty years building a reputation among artists and observers of art as one of the main men, but to the rest his contribution is pretty well totally invisible. What follows may confirm every prejudice you have.

Applications was a performance in which Acconci collaborated with a man and a woman. It took place in December 1970 and was documented on Super 8 colour film. There is no soundtrack and it lasts twenty minutes. A woman, Kathy Dillon, puts on a lot of lipstick and kisses Acconci's torso and arms all over; he then rubs himself up against the artist Dennis Oppenheim's back, transferring the colour to him – end of performance. *Broad Jump* was a performance that also involved the help of friend; it was made in May of the following year at Convention Hall in Atlantic City, New Jersey. This work involved an extreme element of audience participation; Acconci challenged members of the audience to out-long-jump him while offering as the winner's prize an opportunity to procreate with one of his two

girlfriends. The third work I will leave to the art critic Kate Linker to describe: in a fifteen-minute film entitled *Openings*, 'a naked Acconci pulled out hairs from around his navel, thereby clearing out or opening a space that exposed him to penetration by the viewer'.

Also at work during the 1970s was Chris Burden, an East Coast American artist who framed some full-on professional versions of what boys get up to in the back yard during the long summer vacation. On 19 November 1971 he asked a friend to 'almost shoot him'; the friend actually did. Two years later, in September, he crawled naked with hands behind his back through fifty feet of broken glass (documented on sixteen-millimetre film, no audience to speak of present). On 5 January 1973 he tried to shoot down a civilian airliner with a handgun. In April 1974 he had himself nailed to the back of a VW Beetle with his shirt off, while the engine was run at full throttle for two minutes. Then, the next month, he tried not to drown himself by breathing water.

The artist Marina Abromovic also offers us a more or less full range of stances. Apart from nudity, self-wounding and apparent near-death experiences involving blades, guns and bows and arrows, she undertakes feats of endurance with reptiles – for example, sitting dead still with a couple of sleepy pythons curled around her head like a turban as, before the audience's eyes, the animals slowly wake and unravel.

Installation and Intervention

During the latter half of the twentieth century considerable effort was put into moving sculpture away from the limitations of placing an object on a plinth and into a confrontational relationship with the 'room' and the audience. In order both to create and display their ideas, artists took over a whole architectural space in order to make art. They used light and projected images and (often wilfully, sometimes accidentally) clouded the distinction between the real and the artificial, the art and the space where it was shown. In short they rediscovered the diorama. As they excavated the floors and at other times penetrated the walls with objects, the gallery was treated more like a canvas than a frame.

Index of Names

Index of Works